David D. Mulke

1977

THE DARKER BROTHER

THE DARKER BROTHER

James A. Warner
Styne M. Slade

A Dutton Visual Book / E.P. Dutton & Co., / New York / 1974

The authors wish to express their gratitude to these writers, publishers, and copyright owners for their cooperation in the preparation of this volume. Any errors or omissions that may have inadvertently occurred will be corrected in any subsequent printings upon notification to the author.

From **Talking to Myself** by Pearl Bailey, New York: Harcourt Brace, and Javanovitch, Inc. 1971.

From **Only in America** by Harry Golden, New York: Thomas Y. Crowell, and Co., Inc. 1944.

From **The South Goes North** by Robert Coles, New York: Delacourt Press. 1972.

From **Born Black** by Gordon Parks, Phila., Pa.: J. B. Lippincott Company. 1971.

From **Racism** by Robert Froman, New York: Delacourt Press. 1972.

From **The Invisible Man** by Ralph Ellison, New York: Random House, Inc. 1952.

From **Crime In America** by Ramsey Clark, New York: Simon and Schuster, Inc. 1970.

From **Our Faces, Our Words** by Lillian Smith, New York: W. W. Norton and Co., Inc.

From **Unbought and Unbossed** by Shirley Chisholm, Boston: Houghton Mifflin, 1970.

Malcolm X, from **By Any Means Necessary** by George Breitman, New York: Pathfinder Press. 1970.

From **Trumpet of Conscience** by Martin Luther King, New York: Harper-Rowe, 1968.

Published simultaneously in Canada by

Clarke, Irwin & Company Limited

Toronto and Vancouver

ISBN: 0-525-49502-9

Library of Congress Catalog Card Number 74-3639

Printed by Vernon Martin Associates, Inc., 1812 Hempstead Road, Lancaster, Pa. 17601

Our venture was a gratifying one and certainly made easier because of
our association with Fred and Sheila Rouf—and Mary E. Banks.
We dedicate this book to the three of them and know that
when our world can keep pace with them and people like them
"the dream" and "brotherhood" will be an actuality.

It really boils down to this: that all life is interrelated. We are all caught in an inescapable network of mutuality, tied into a single garment of destiny. Whatever affects one directly, affects all indirectly. We are made to live together because of the interrelated structure of reality. Did you ever stop to think that you can't leave for your job in the morning without being dependent on most of the world? You get up in the morning and go to the bathroom and reach over for the sponge, and that's handed to you by a Pacific Islander. You reach for a bar of soap, and that's given to you at the hands of a Frenchman. And then you go into the kitchen to drink your coffee for the morning, and that's poured into your cup by a South American. And maybe you want tea: that's poured into your cup by a

Chinese. Or maybe you're desirous of having cocoa for breakfast, and that's poured into your cup by a West African. And then you reach over for your toast, and that's given to you at the hands of an English-speaking farmer, not to mention the baker. And before you finish eating breakfast in the morning, you've depended on more than half of the world. This is the way our universe is structured, this is its interrelated quality. We aren't going to have peace on earth until we recognize this basic fact of the interrelated structure of all reality.

Martin Luther King, Jr.
A Trumpet of Conscience

Preface

This is a gentle book — about a subject that many people feel is quite violent. I have studied Jim Warner's warm, humane photographs and chosen passages without rancor because I believe strongly — "militantly" if you will — that there is another side to be seen and another story to be told.

I am a black American woman. But I think of myself as Styne Slade first: as a person, apart from color or race or sex or nationality. I try to see others as persons, and I hope they see me that way, too. But my experience — all my knowledge and awareness — has taught me that barriers are there. This book is an effort to help people to open their eyes, to see the beauty they might have missed until now. To know the uniqueness of a person, black or white: that is why these photographs and these quotations come together.

I am a child of the city, a product of the ghetto. I was fortunate in not knowing that this made me different. It was just the way I lived, and I was not unhappy there. I was luckier than most, too, in having many opportunities to travel. I saw a lot of my country, and it was **my** country. I felt American, and equal, and special in the way that children who are loved know that they are special. I saw that some people scorned me. But children are always taught to be wary of strangers, and to look out for "different" people, and so I looked upon the scorners, not upon myself, as different.

I cannot say exactly when I came to realize that "whites" looked down upon "blacks." I do know that I felt this not so much as a personal slur, but more as a social injustice. As a caring person, I tried to correct it. I took part in sit-ins, in marches, in demonstrations. This is my world, and I bear a responsibility for the well-being of all the people in it. I hope,

and I truly believe, that I would have marched if my own skin were not black. We must look at other people, and if they need help, help them.

Of course I have felt discrimination. And I have felt the warmth of being. I have felt the special sting a parent feels when a child is isolated and belittled and numbed. And I have seen my children grow into warm, responsible adults. I have felt the nervousness of people who "try to be nice to Negroes." And I have witnessed the astonishment of whites who discover the highly developed, proudly lived social regimen of middle class black America.

Just as I have felt discrimination, I have felt and seen black people hurt our own brothers and sisters. I have seen angry black militants alienate people of all races just as I have experienced the degrading insulting, dividing stings hurled by angry whites. I have witnessed black leaders who evaded leadership when the chance to lead was theirs. I have cringed when a "dutiful" black belittled himself to meet the expectations of whites, and I have experienced a world in which status-conscious blacks demeaned blacks "lower" than themselves.

I have seen these things, and I have lived them. But there are new things to see now, new perspectives to gain, new beauties to behold. The Sixties are over. Some things have been gained; others are lost. We do not have all the answers, but we do have a new vantage point. Blacks and whites are not sure of each other any longer, and that is good. You cannot take for granted what you are not sure about.

Let this book help all people to look, to take the first step in learning what for so long we didn't care to know. This is a book about beauty. It is not a polemic for a cause. It says merely, "Come and see. Judge for yourself. Look at individuals. Look at persons."

Styne Slade

*When the Kerner Commission blamed the riots on
"white racism," a howl of protest went up
from coast to coast.
The truth always hurts
but in this case it hurt a bit more,
because people don't fully understand
what racism is.
Most whites are immediately angered
because they interpreted racism as joining
lynching parties,
not wanting Negroes to sit beside them in a bus,
or using racial slurs.
But that's not racism,
that's insanity
Racism is the assumption of superiority
and the arrogance that goes with it.*

Whitney M. Young, Jr.
Executive Director
National Urban League

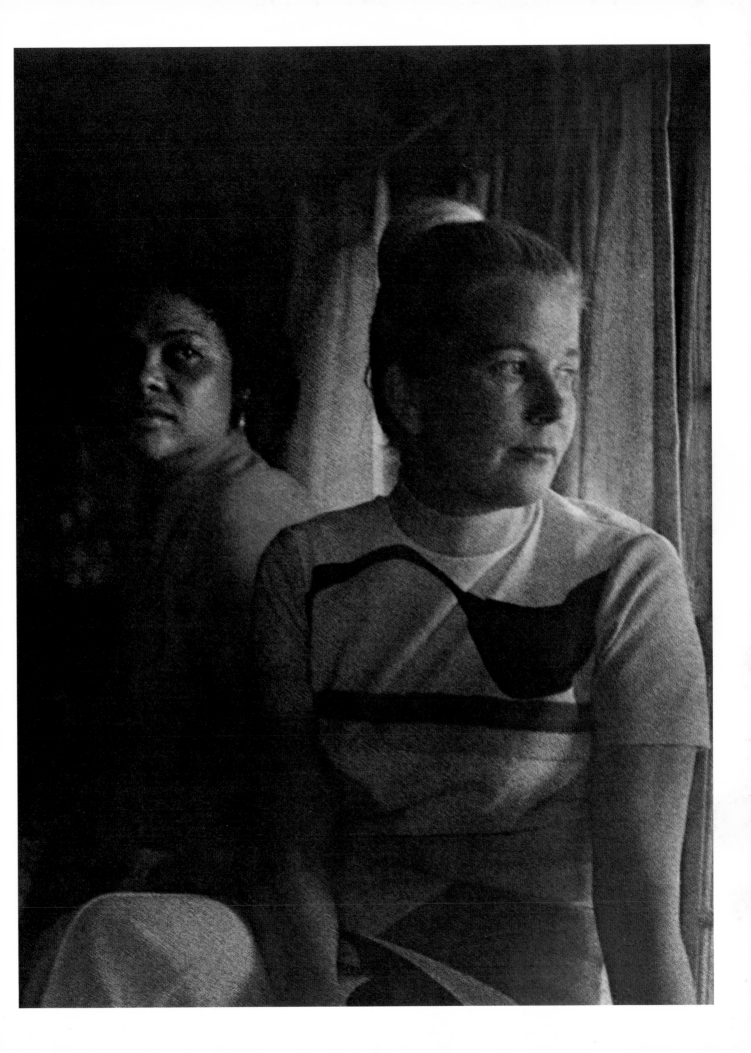

Whenever we cheat any segment
of our population;
we cheat ourselves.
Forty years ago Northerners were amused by the
clever devices used in the South
to keep Negroes from voting or
getting an education,
and so long as Negroes remained in the South
the contrivances remained comic.
But when large numbers began arriving
in northern cities, uneducated and unprepared,
Northerners awakened to the fact that
now they were going to pay the bill
for those decades of southern neglect.

James A. Michener
Author *Quality of Life*

4

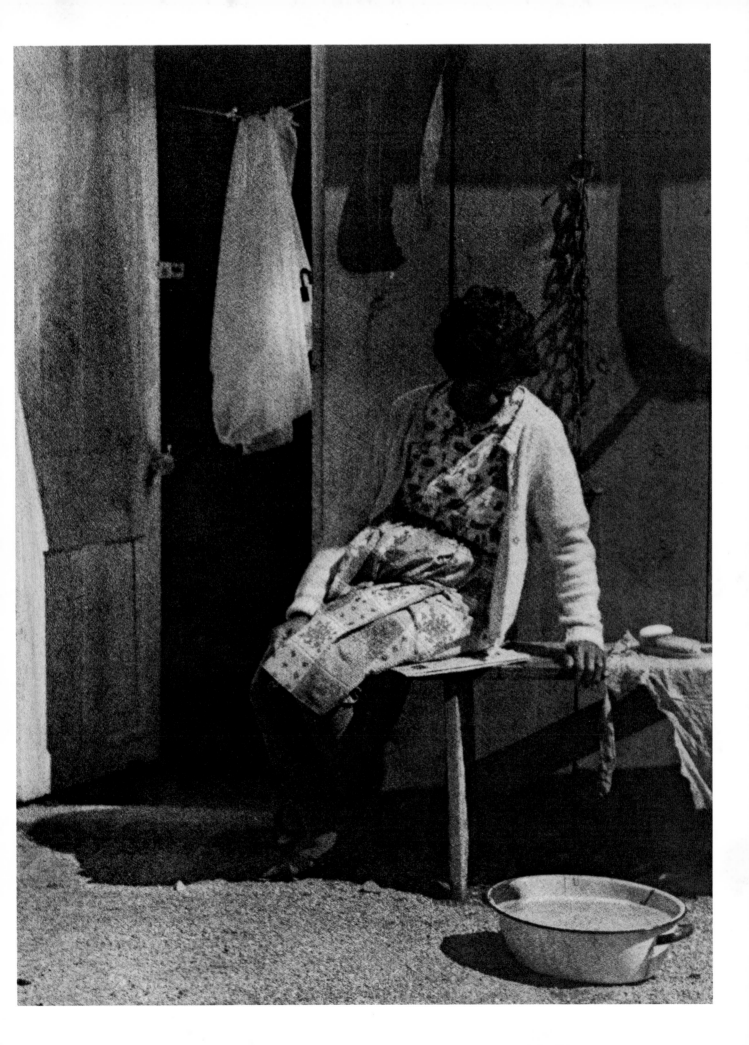

*Our people are our most precious possessions
and we cannot afford to waste the talents
and abilities given by God, to one single one.*

*I say to you quite frankly,
that the time for racial discrimination is over.
No poor, rural, weak, or black person
should ever have to bear the additional burden
of being deprived of the opportunity
of an education,
a job or simple justice.*

Jimmy Carter
Governor, State of Georgia

6

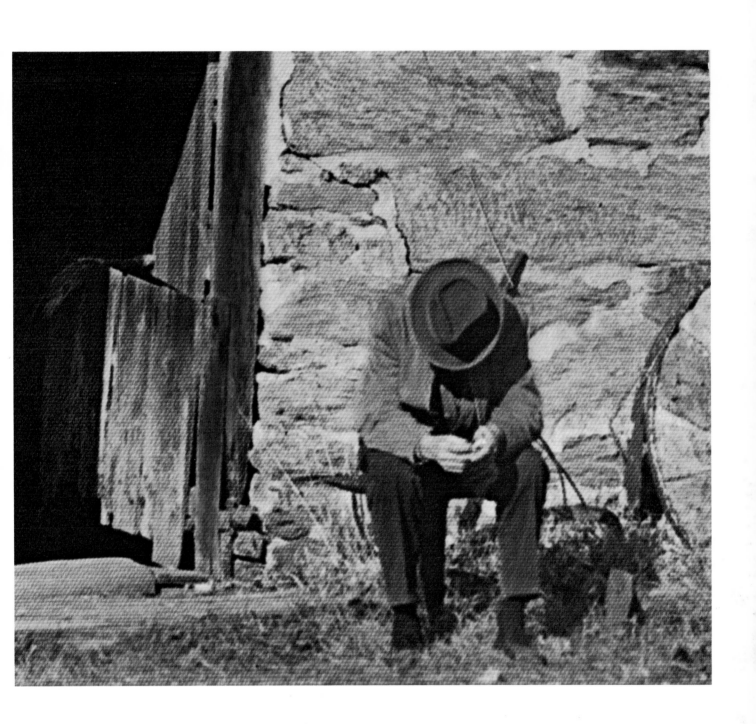

The problems of poverty are not black alone.
There is hunger in the tenements and
shacks of whites and browns and reds as well.
There is misery in Appalachian ghost towns,
in the barrios of the west,
in migrant labor camps and in
Indian reservations.

Whitney M. Young, Jr.
Executive Director
National Urban League

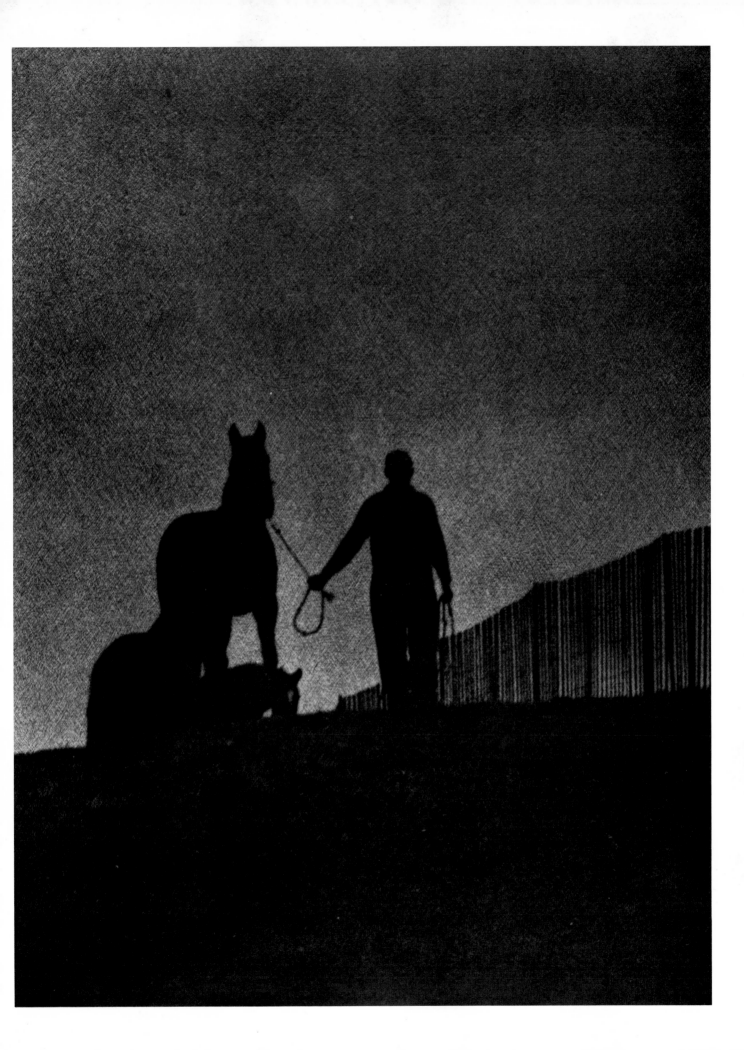

The proud black spirit seeks justice and decency.
It seeks to move beyond racism
to a new era of progress and reconciliation.
It seeks power not for its own sake,
but in order to use it wisely and
to prevent its misuse by racism.

It seeks peace with honor, justice with respect.
It seeks a new world and a better tomorrow.

Whitney M. Young, Jr.
Executive Director
National Urban League

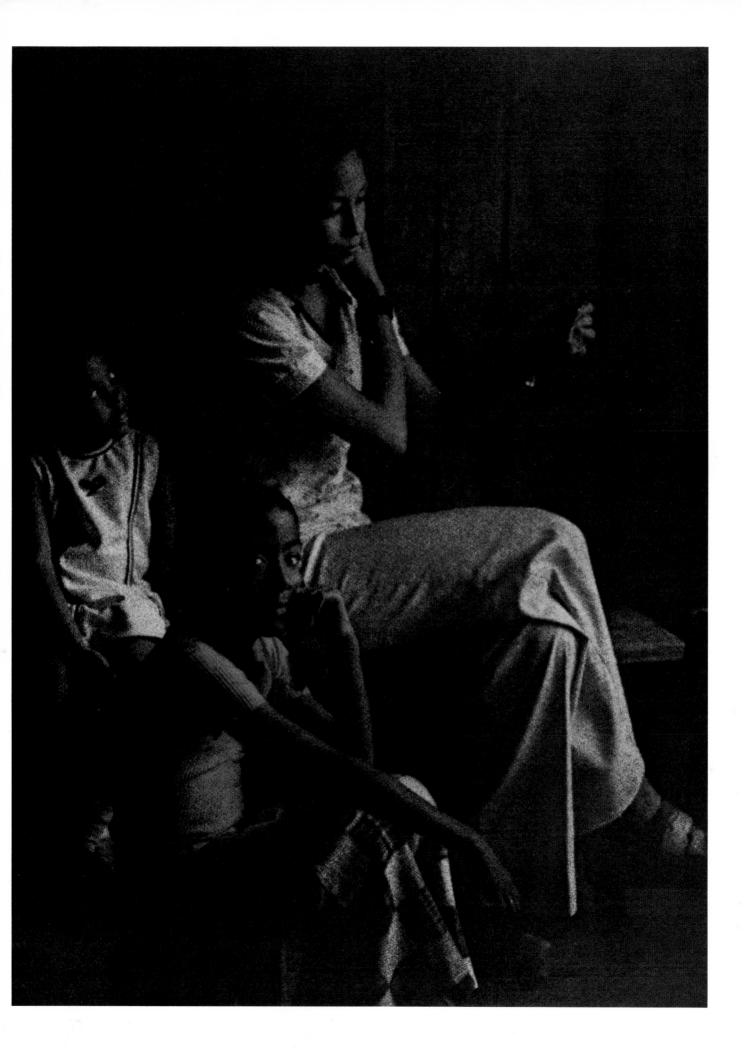

People do not willingly uproot themselves
from a homeland centuries old and deeply loved.
But having made a decision to flee
failing agricultural economies discrimination,
and grinding poverty,
they bring north with them a faith
in America
that is often shattered in the ghetto,
which proves to be no promised land at all.

Robert Coles, M.D.
Author *The South Goes North*

*The United States of America is a country
which produced the Marshall Plan,
helped resurrect the spirit and economy
of Europe with great dedication
and billions of dollars.
We have come to the aid
of the refugees of the world.
What man can say that this great country
with its democratic ideals,
its vital and resilient spirit,
its sophisticated resources,
cannot bring an end to racial discrimination
at home now and within a decade or two
the other disabilities
under which for so long so many
Negro citizens have labored.*

Mathew Ahmann

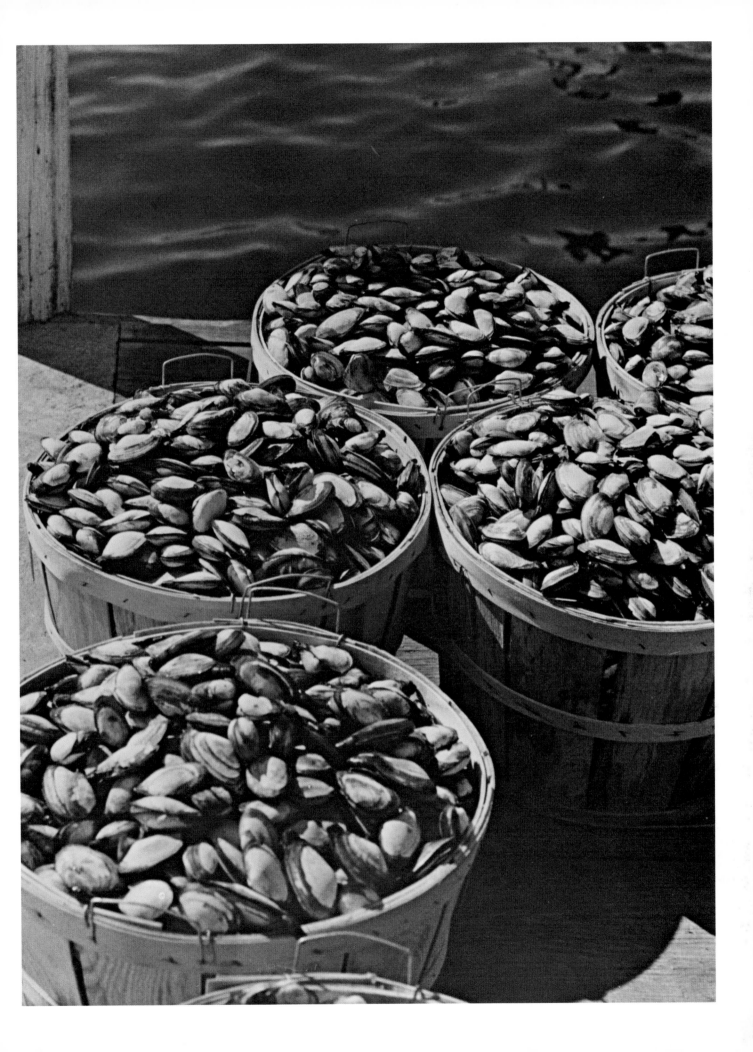

There are far too many in America
today who have been denied
their chance to do something for this country.
Some of the reasons of denial
I do not know.
But it is a fact that amongst far too many
of our youth, and particularly among Negro youth,
unemployment runs as high as
thirty-five percent.
The unemployed young people stand idly
on a street corner bitter,
and listening all too often
to the purveyors of division and hate.

Hubert H. Humphrey
Vice-President, United States

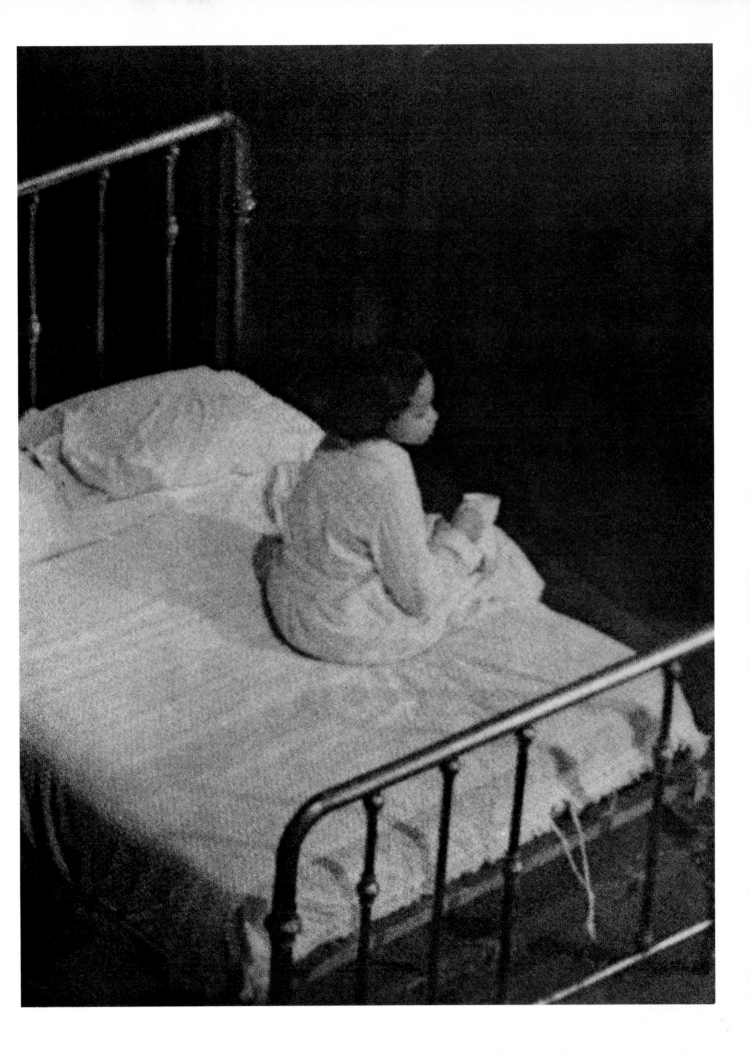

*Whenever or wherever people divide themselves,
or lose concern for one another or
build priorities of money,
or power, or possessions
and put them above people together,
then there will be blight
and problems and confusion,
hence our situation today.*

Thomas A. Peters
Education Co-Ordinator
Child Care Conference 1971

*"You strike out with your fist,
you curse and you swear
and you go to war with society only
because society has arrayed itself
against you ever since you discovered
that the color of your skin
carried a shameful denial of your right
to be treated as a human being.*

Ralph Ellison
Author *The Invisible Man*

Today the first duty of responsible citizens
is to bind together
rather than tear apart.
The fissures in our society
are already dangerously deep.
We need greater emphasis on the values
that hold us together.

John W. Gardner, Secretary
Health, Education and Welfare

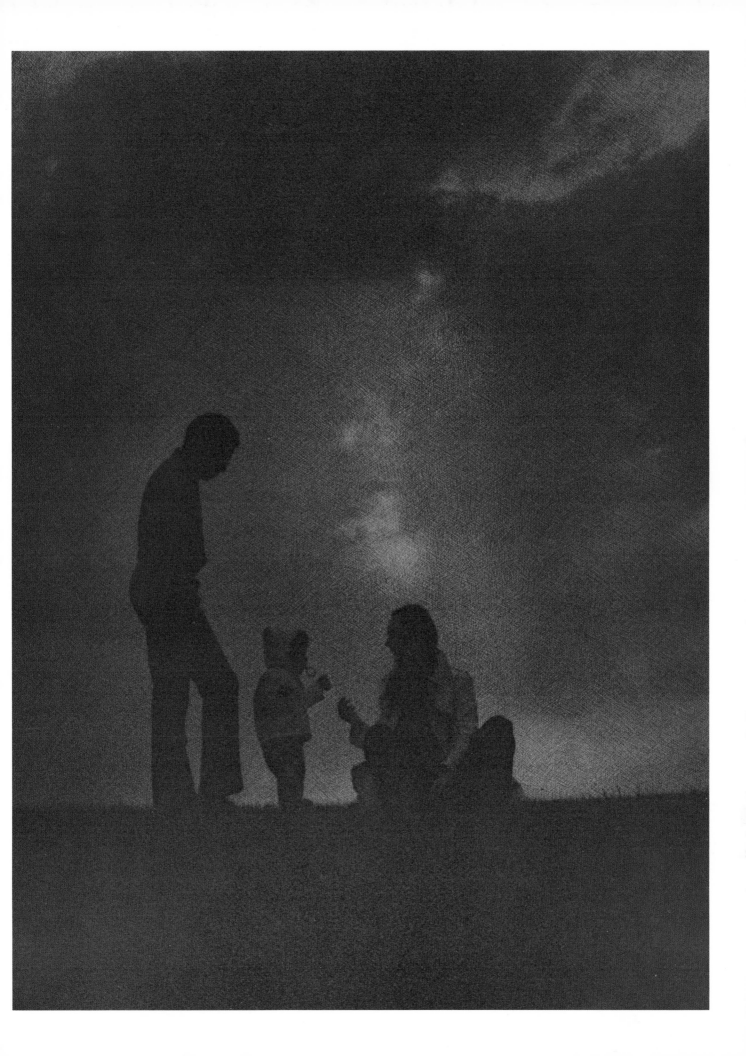

. law alone cannot make men see right.
We are confronted primarily with a moral issue.
It is as old as the scriptures
and is as clear
as the American Constitution.

John F. Kennedy
President of the United States

24

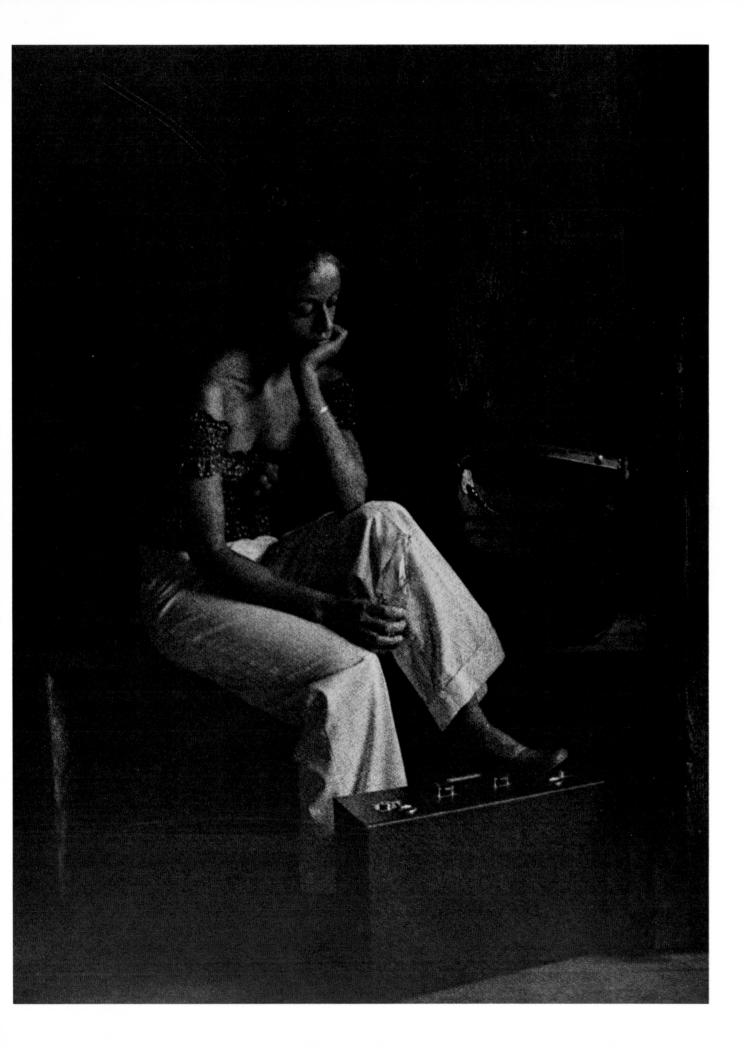

It will be neither our cleverness nor
our virtue which will bring us through this
struggle for human rights,
but the power of God.
It is for us to remind ourselves
of the propositions of our faith.
For while there is a little black Muslim
in every Negro and a little of the
Ku Klux Klan in every white man,
there is also the cleansing power of God.
This struggle belongs to all of us
and we can engage in it with the confidence that
our victory is the will of God.

Gerald Kennedy
Methodist Bishop and Author

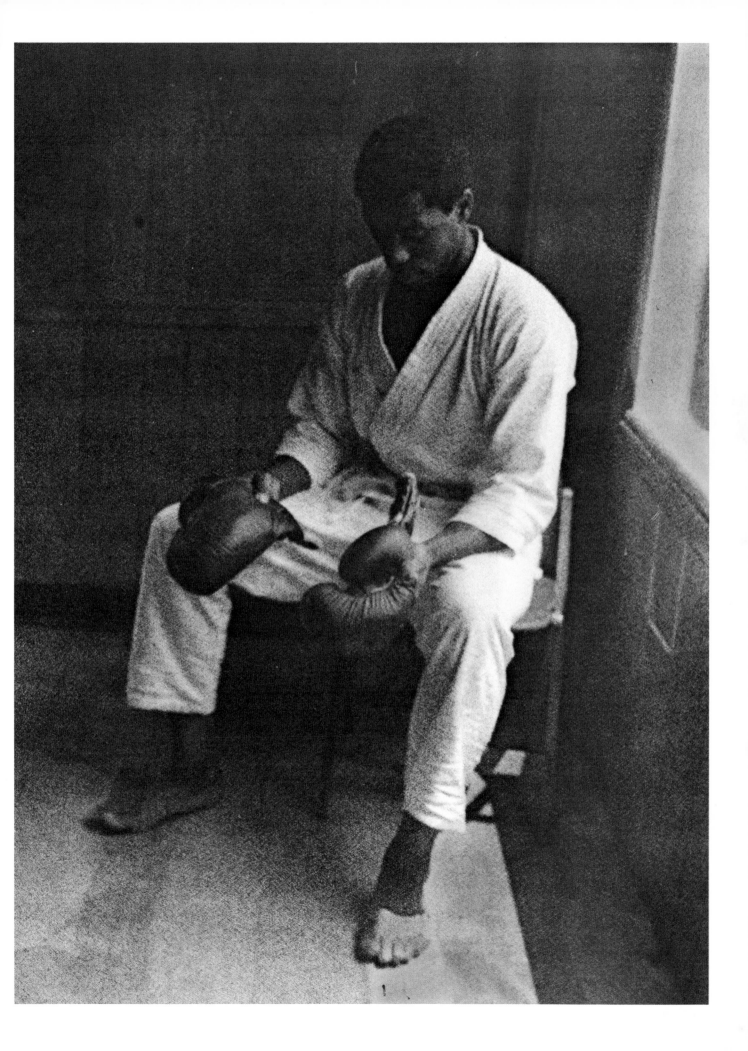

*One thing is certain
in a plexus of uncertainties and that is,
our encounter with the future cannot be evaded,
it must be met by both the artist and the scientist
in us, by our deep intuitions
and our rigorously proved knowledge — and
by the human being in us,
too that creature who knows the power
of compassion, the potency of a strange love
that keeps reaching out
to bind one man to another.*

Lillian Smith
Author *Our Faces, Our Words*

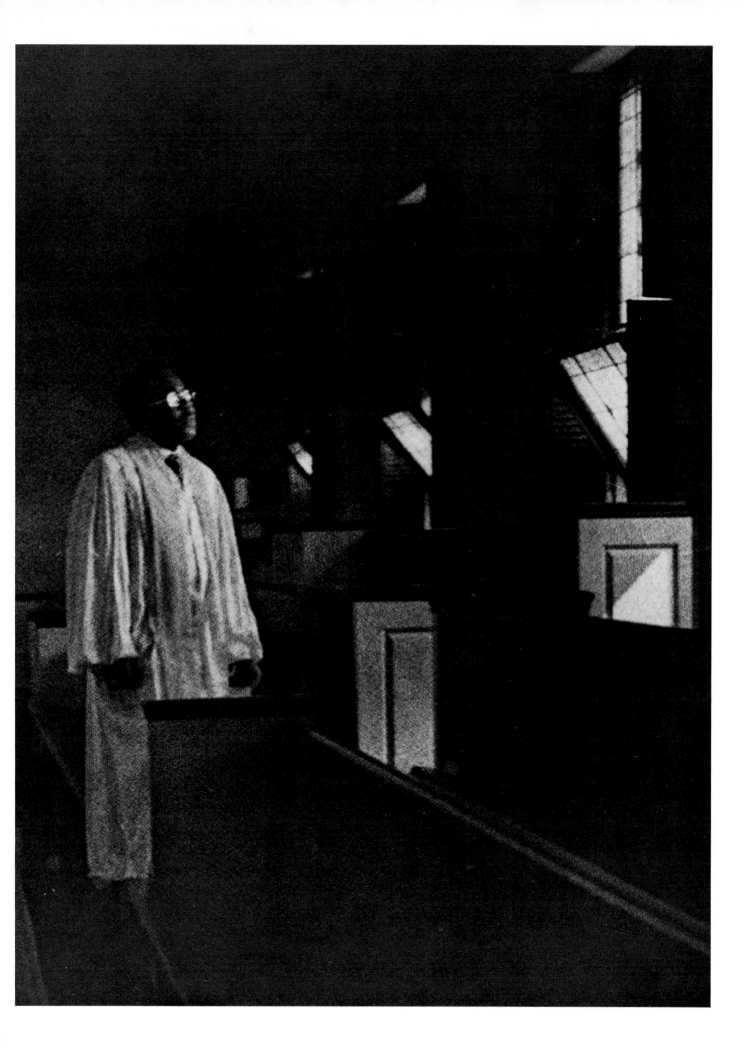

*The shameful facts of discrimination
against black people
have been set before the nation,
but I wonder how many are fully aware
of the scandalous and
all pervasive discrimination
against women of all colors.*

Bella Abzug
Congresswoman
New York State

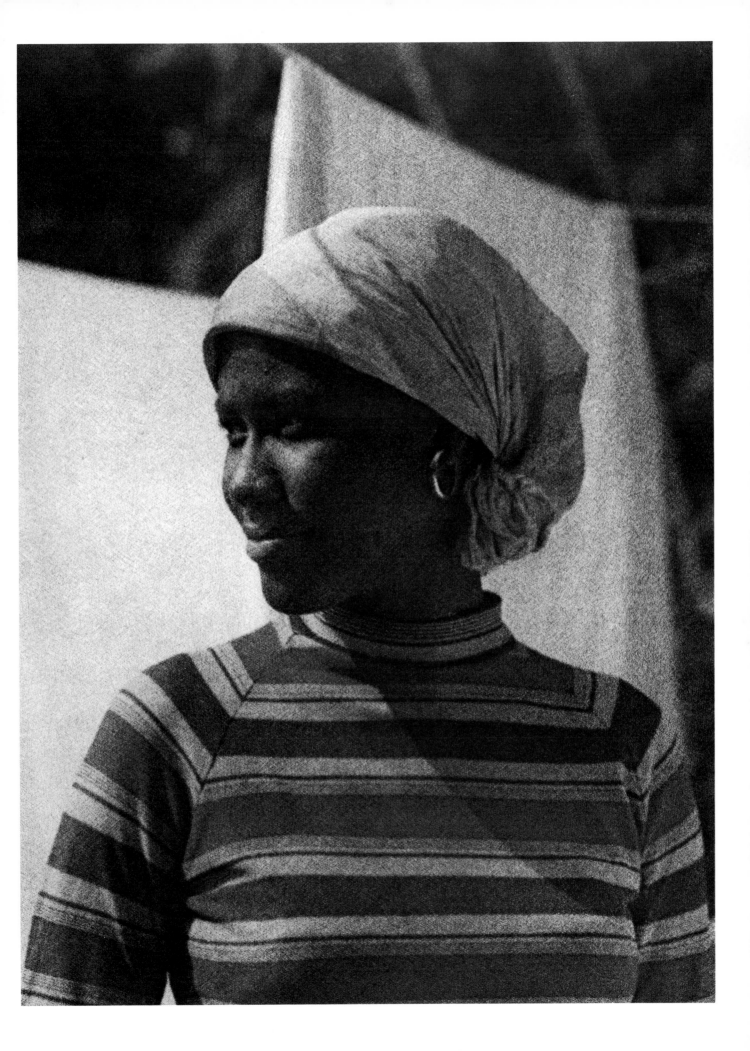

*"It will be a great tragedy
if the Black Woman is forced
to choose between being Black
and being a woman.
Being Black does not negate
her womanliness, and being a woman
does not negate her Blackness."*

Sandra Haggerty
Newspaper columnist

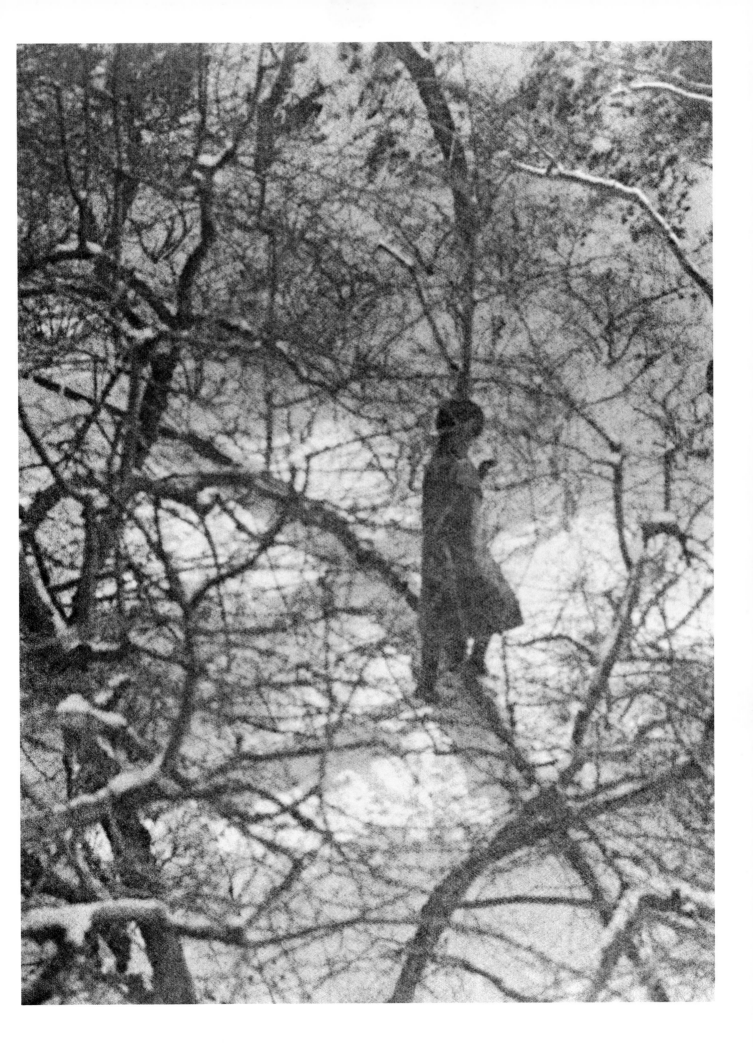

To meet them — —
— to help people want to learn,
want to work, want to live,
one must work out a very real
relationship with them;
it is not enough to give them
hand-outs of food, things, books;
one must give concern, understanding —
this is the only bridge these tremulous,
quietly raging people can walk across.

Lillian Smith
Author *Our Faces Our Words*

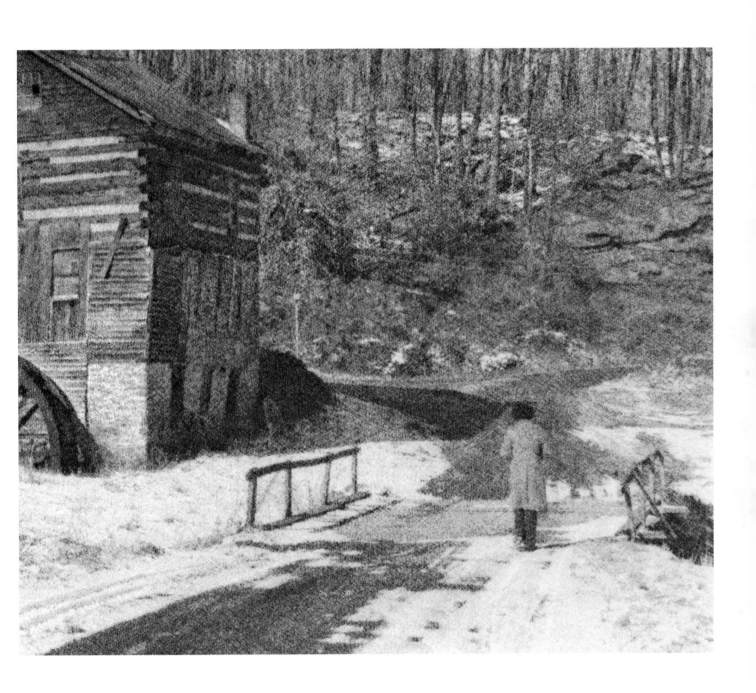

*Education is an important element
in the struggle for human rights.
It is the means to help our children
and our people rediscover their
identity and thereby increase self-respect.
Education is our only passport
to the future, for tomorrow belongs only
to the people who prepare for it today.*

Malcolm X
Founder of the Organization
of Afro American Unity

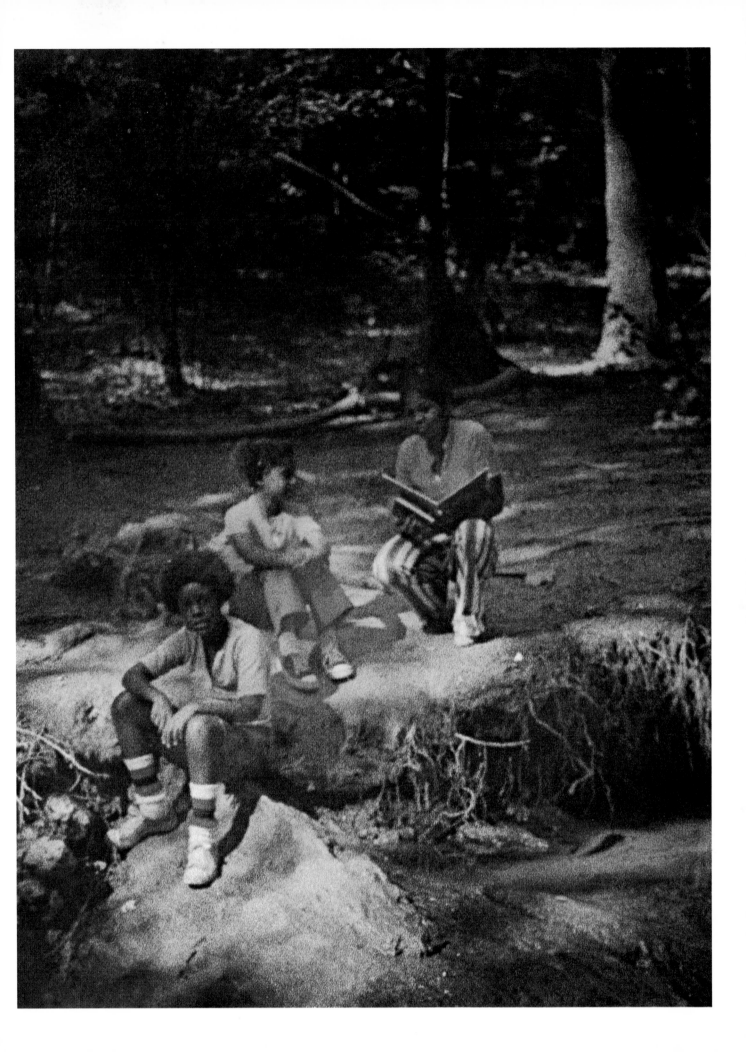

The secret of what to do about ghetto education
is no secret at all; the answer is to change
what we have been doing and change now.
It is astonishing that professionals,
whether writers, teachers, or administrators,
should point to the failure of children as
evidence of the child's inferiority.
What it proves is that the schools,
by retaining processes which
have not worked for decades,
are failing in their job.
Using textbooks, methods, and strategies
to which children will not respond
is as senseless as teaching them
in a foreign language.

Edward M. Kennedy
United States Senator
State of Massachusetts

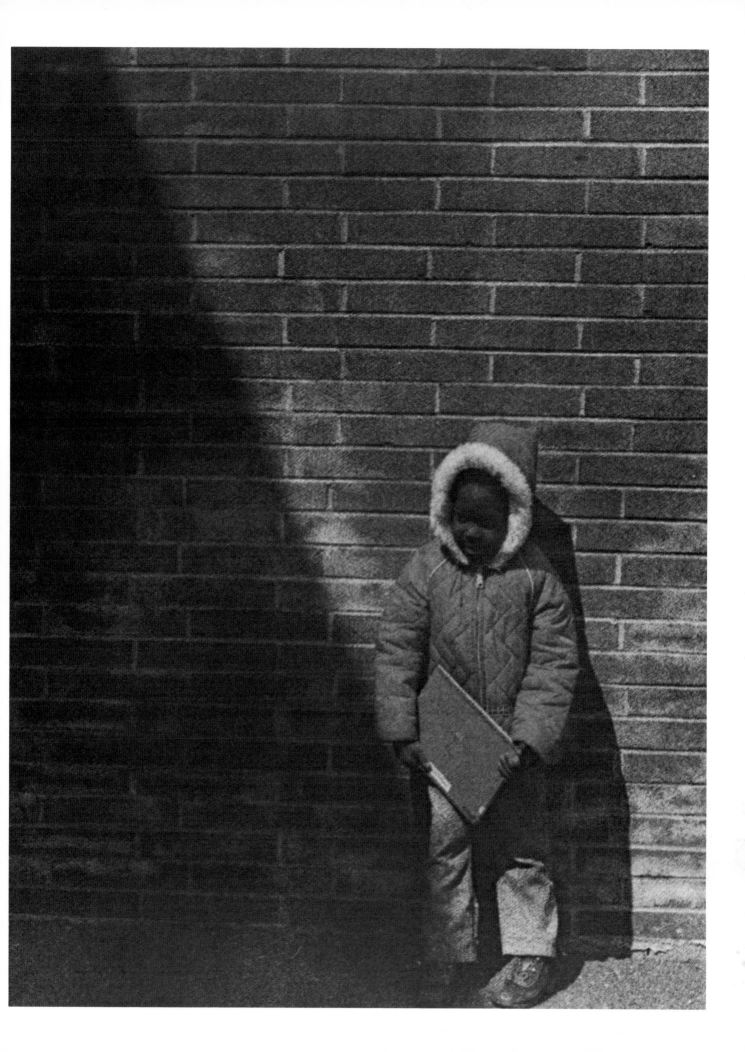

It can be seen throughout our land,
in men without skills,
in children without fathers,
in families that are imprisioned
in slums and poverty.
For it is not enough just to give men rights,
they must be able to use those rights
in their personal pursuit of happiness.

Lyndon B. Johnson
President of the United States

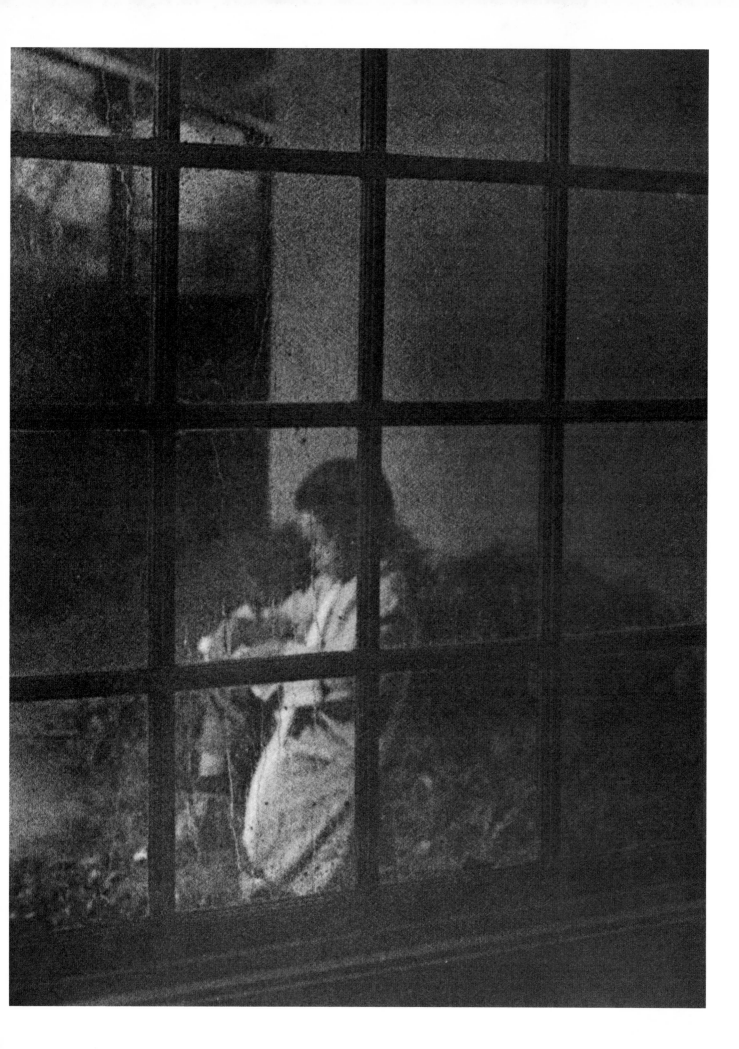

*The tremendous buying power of the
twelve million Negroes in the South
has been based wholly
on the absence of racial segregation.
The white and Negro stand at the same grocery
and supermarket counters;
deposit money at the same
bank teller's window;
pay phone and light bills to the same clerk;
walk through the same
dime and department stores,
and stand at the same drugstore counters.
It is only when the Negro "sets"
that the fur begins to fly.*

Harry Golden
Author *Only in America*

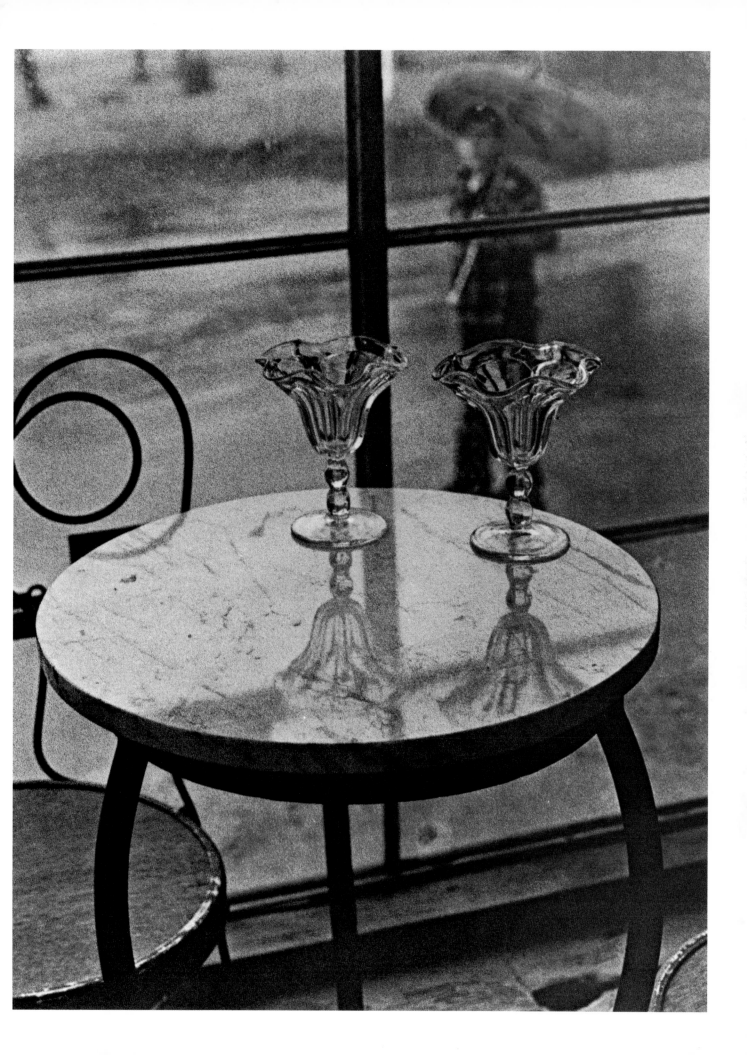

Our record, like that of other countries,
is far from perfect.
But with the decision of our Supreme Court
of 1954 and the decisions since,
in which I hope you will not deem it amiss
if I take great personal pride and satisfaction
as having participated in some of them,
in the passage of the Civil Rights of
1964 and 1965 the American government
has put some concrete form and
terms in full and complete commitment
to the principle of full human rights,
of freedom and equality for all of our people.

Arthur J. Goldberg
Supreme Court Justice

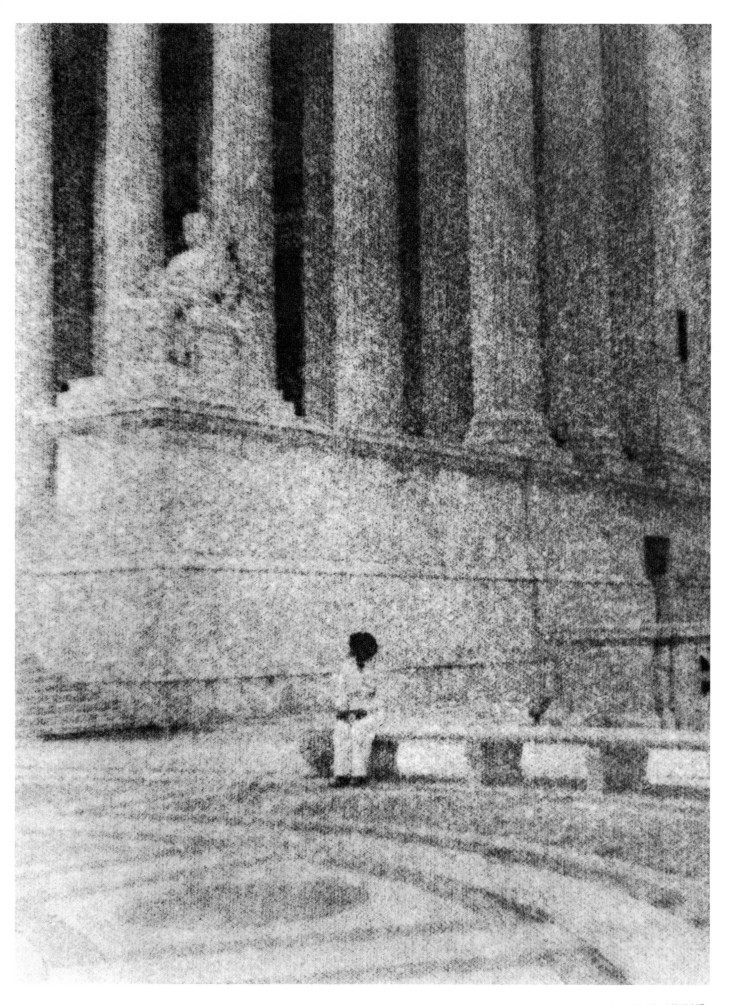

DAVID N. MIELKE

To every man his chance;
To every man, regardless of his birth,
his shining golden opportunity;
To every man the right to live,
to work, to be himself;
To become whatever his manhood and
decisions combine to make him,
That is the promise of America.

Thomas Wolfe, Author

46

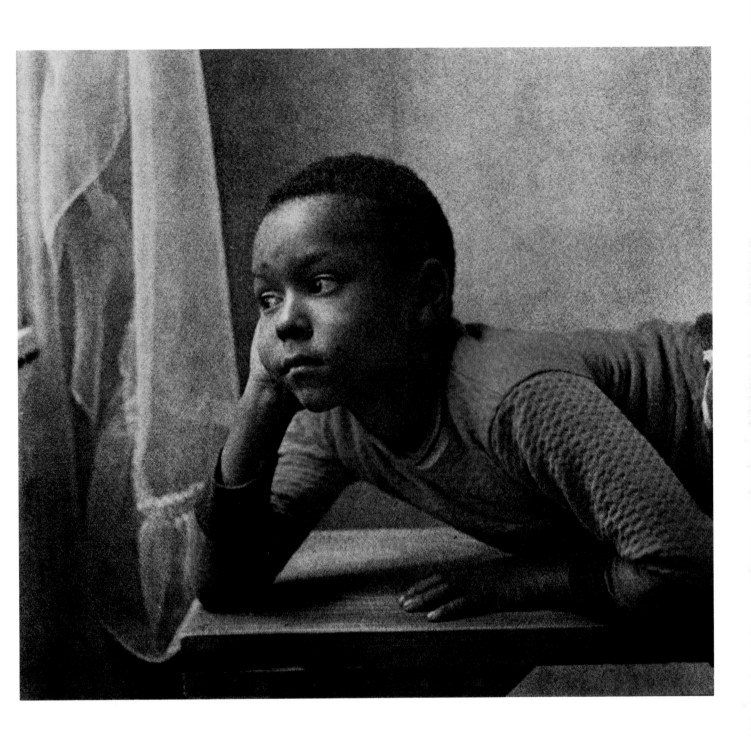

We shall hear no more that voice
we know to have been eloquent.
We shall experience no longer that spirit
we know to have been powerful.
But we as a nation can keep the voice eloquent
and we can keep that spirit powerful
not by continuing to quote from speeches
and books and not by continuing to
recall interesting and important anecdotes
about his life.

In this decade let this nation use its resources
and institutions not only to
land men on the moon,
but on earth to stand men on their feet.

James A. Cheek
President of Howard University

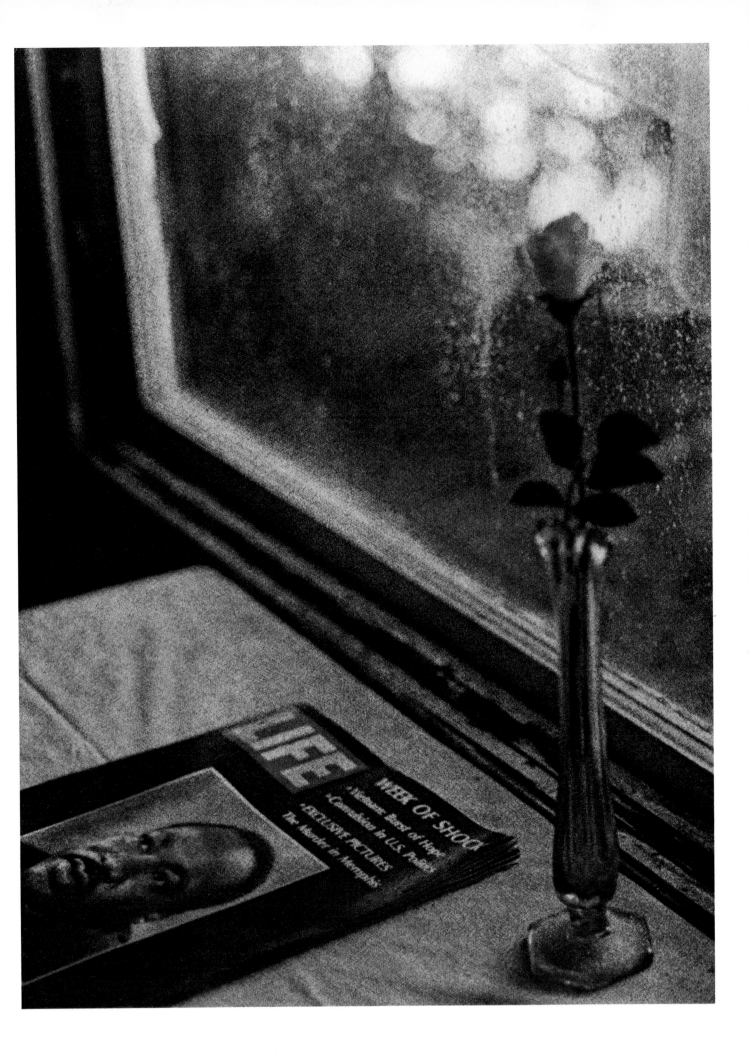

A child shall be protected from practices
which may foster racial, religious and
any other forms of discrimination.
He shall be brought up in a spirit of understanding,
tolerance, friendship among peoples,
peace and universal brotherhood and
in full consciousness that his energy and
talents should be devoted to the
service of his fellow men.

Declaration of Rights of the Child

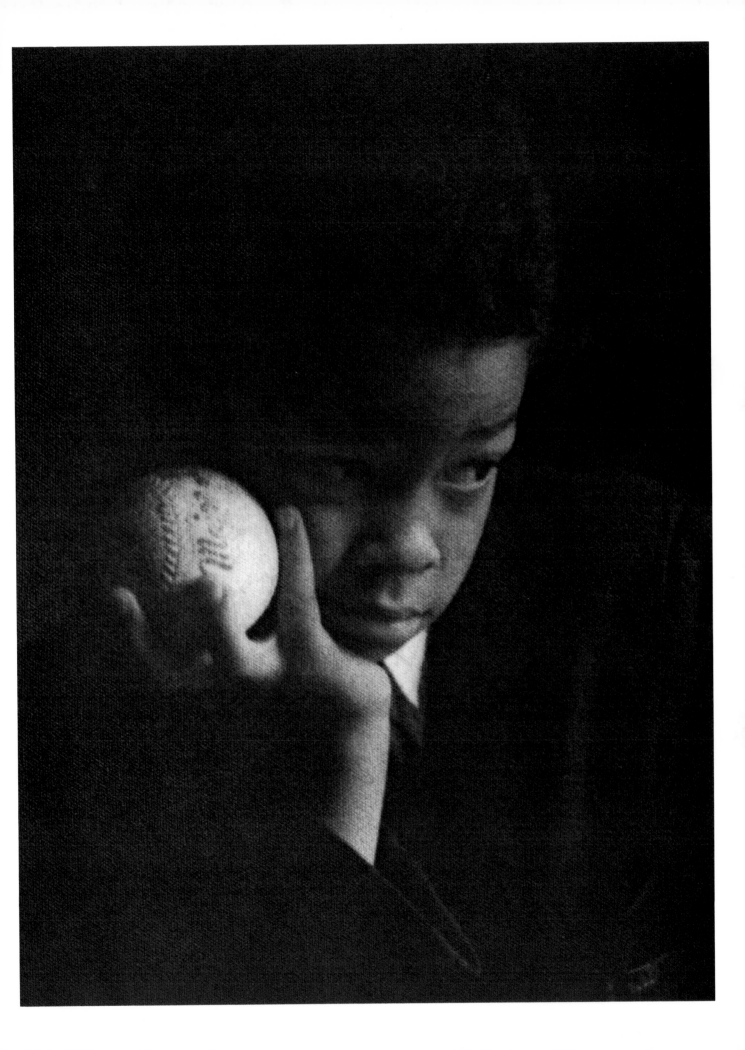

Parents Hear Me
Children are not so frightened by us
as we are by them.
We can thank our own parents,
many of us in this generation,
for what they taught us.
They may have missed a few things,
perhaps they weren't as open with us
about some issues as they might have been.
But I know that they tried
for the good foundations.

Pearl Bailey
Author *Talking to Myself*

52

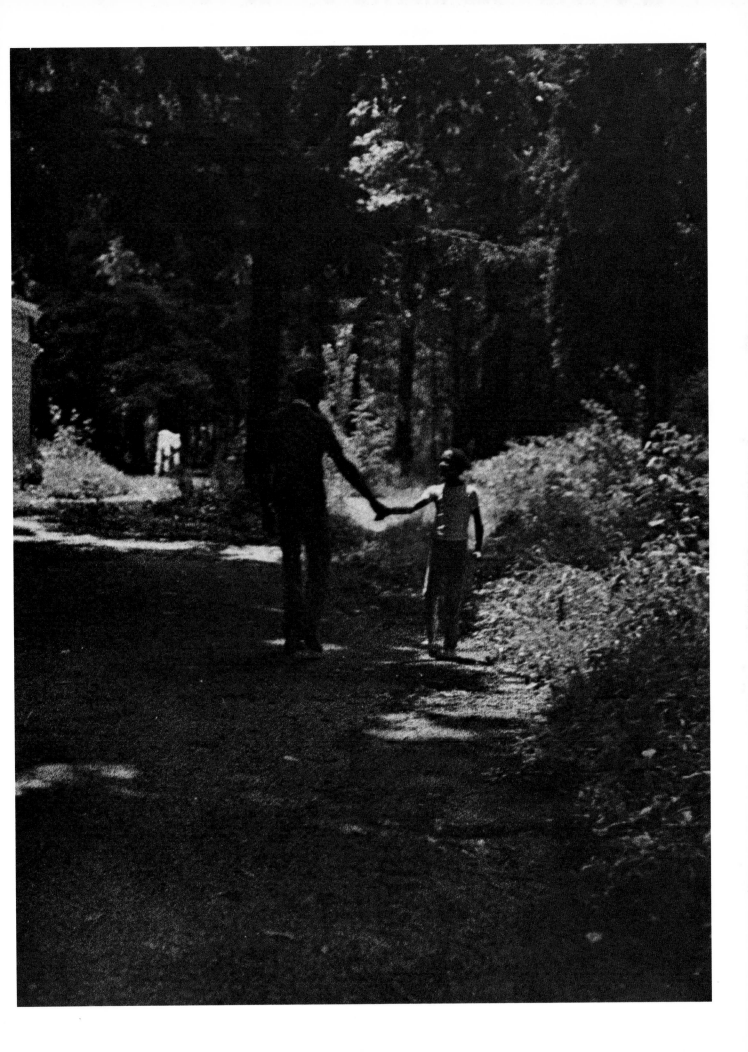

*"You misjudge us
because you don't know us."*

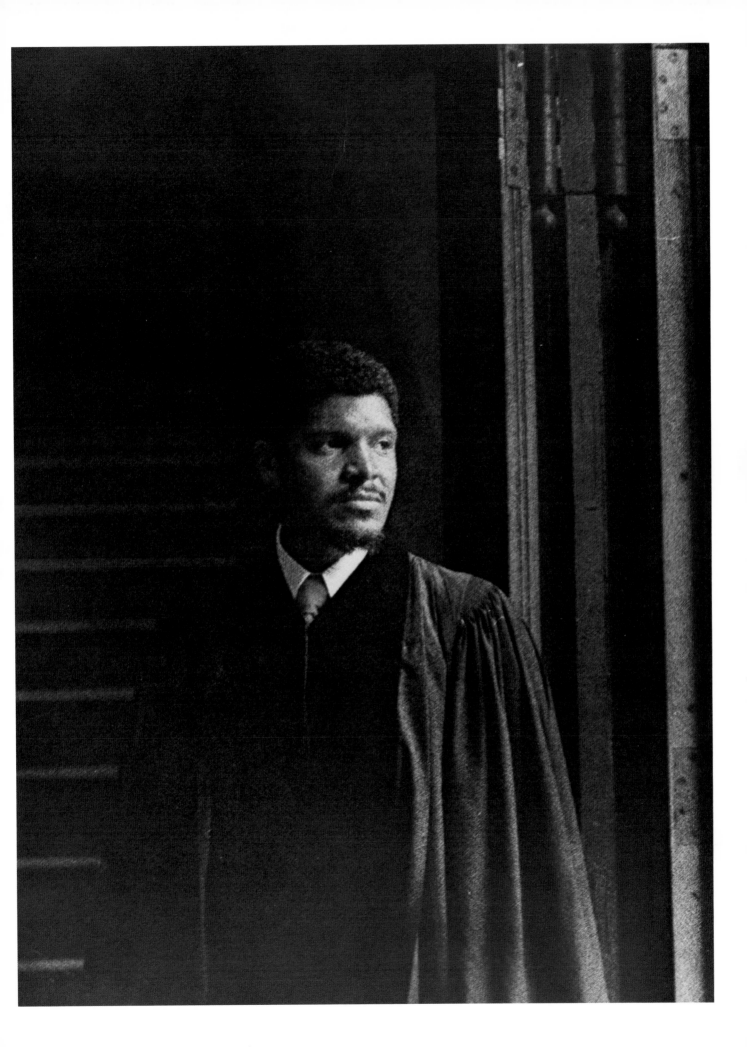

Somehow we all must learn
to know one another.

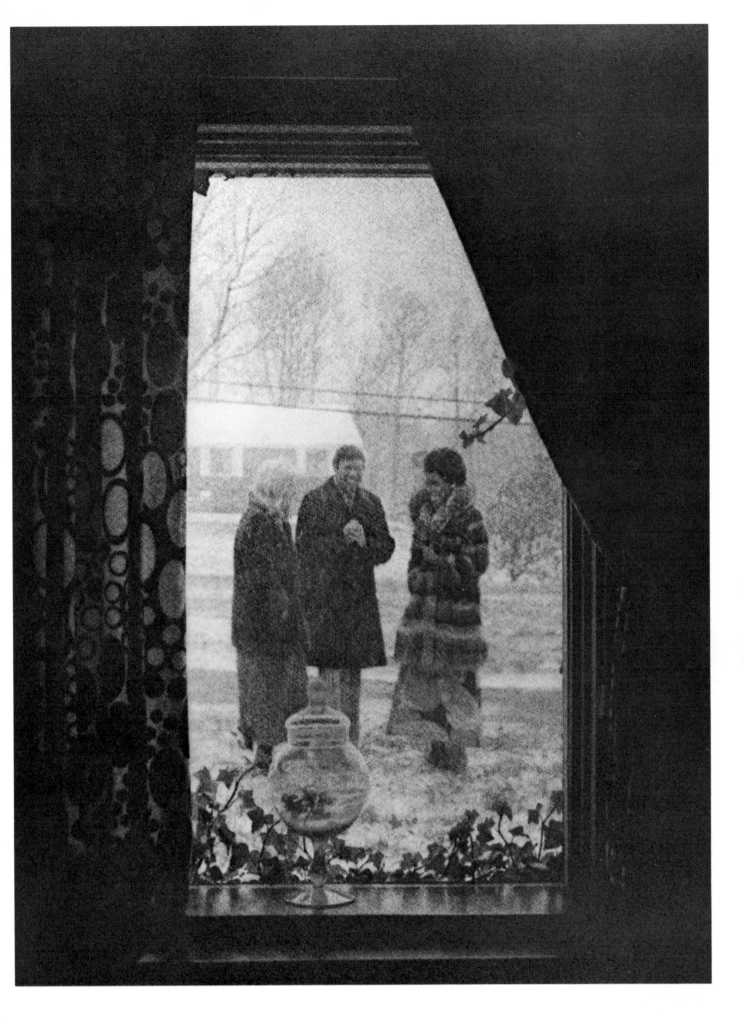

*The church today, existing in a
highly competitive, often critical society,
can thrive and be effective only
when its members are such.
Whatever an individual wants his church
to become, he must himself be.
If it is to be a spiritual haven
he must be personally spiritual.*

G. Othell Hand

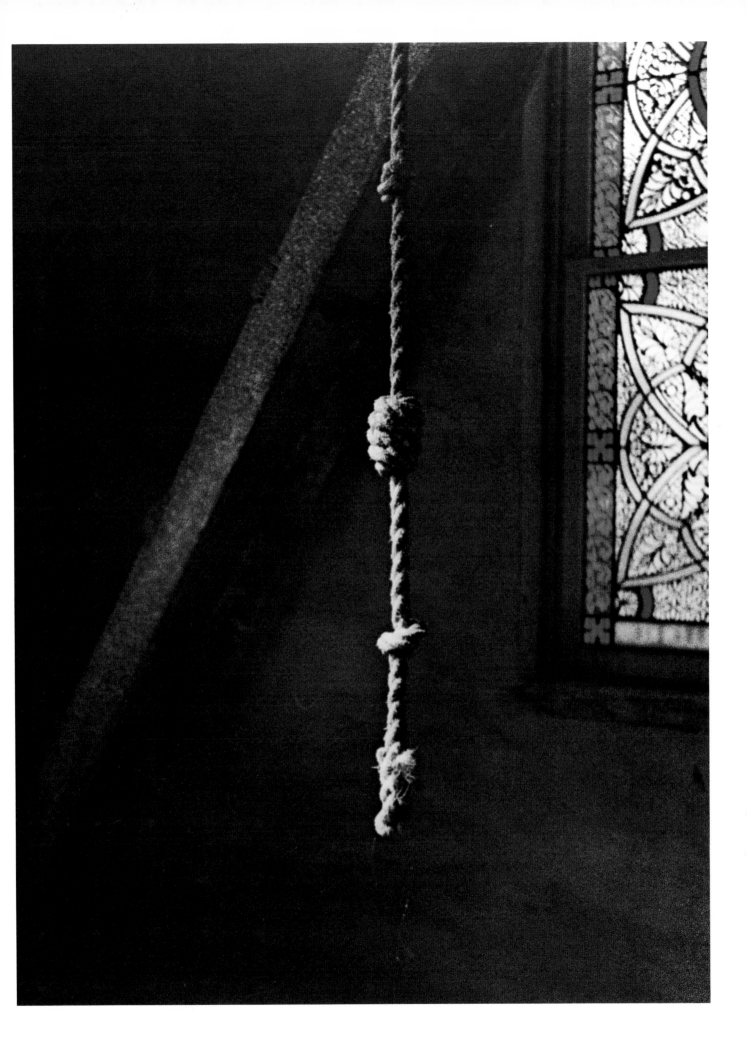

When we think about big things,
let's consider the little ones first,
our children, then build
from these toward bigger things.

Thomas A. Peters
Education Co-Ordinator
Child Care Conference 1971

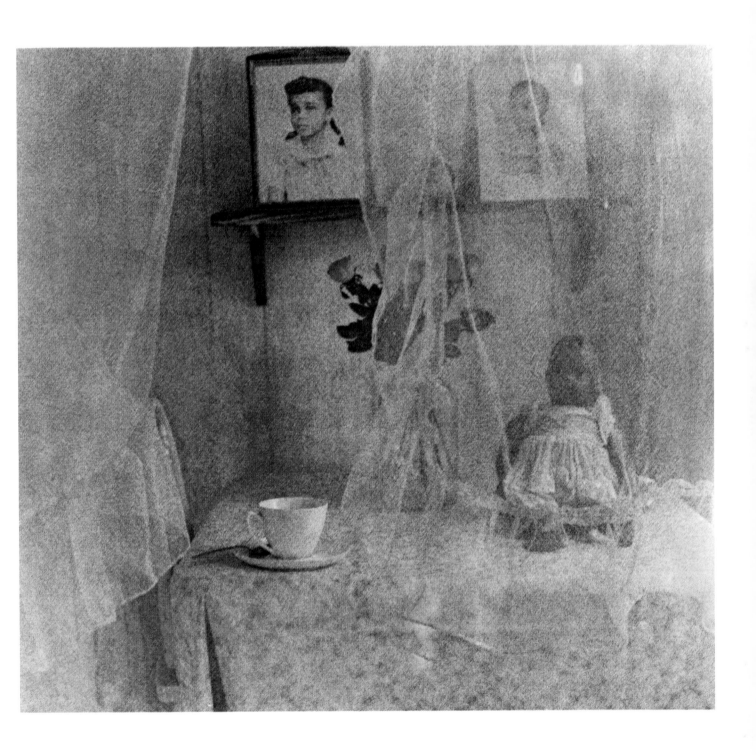

A child might have it in him
to become a tall, strong,
energetic man, and another child
might have it in her to become a
woman of unusual beauty;
but without proper food
neither of them will survive infancy,
let alone reach adulthood.

Robert Coles, M.D.
Author *The South Goes North*

62

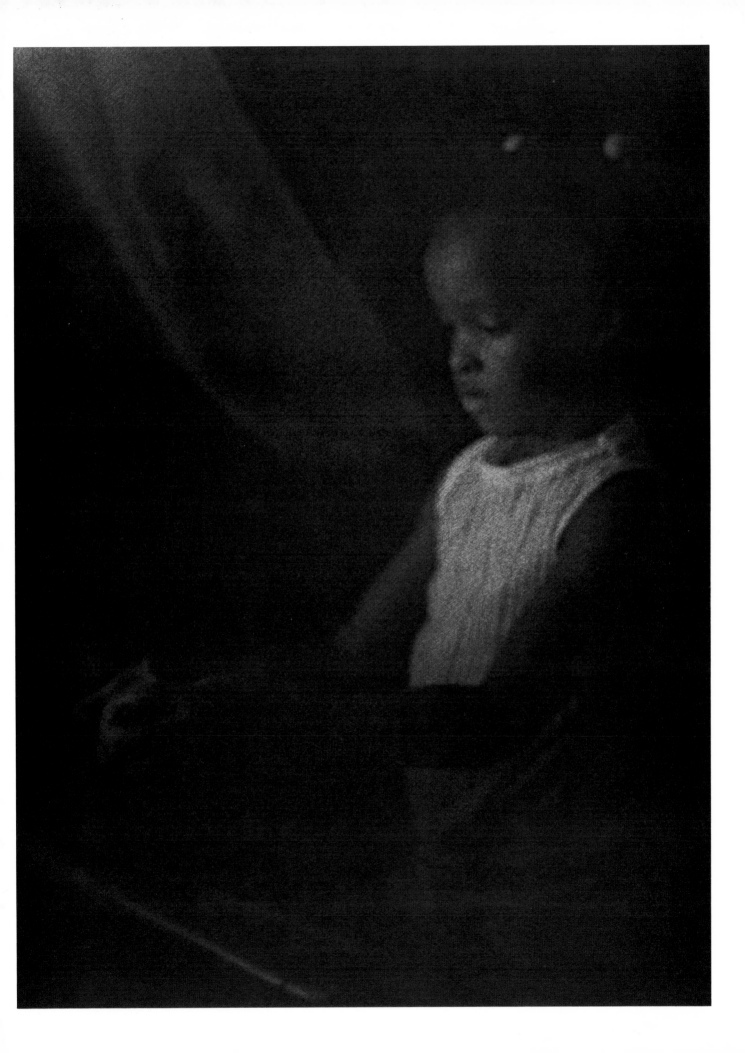

*Probably no other thing
encourages a child to love life,
to seek accomplishment
and to gain confidence,
more than proper sincere praise —
not flattery, but
honest compliments when he does well.*

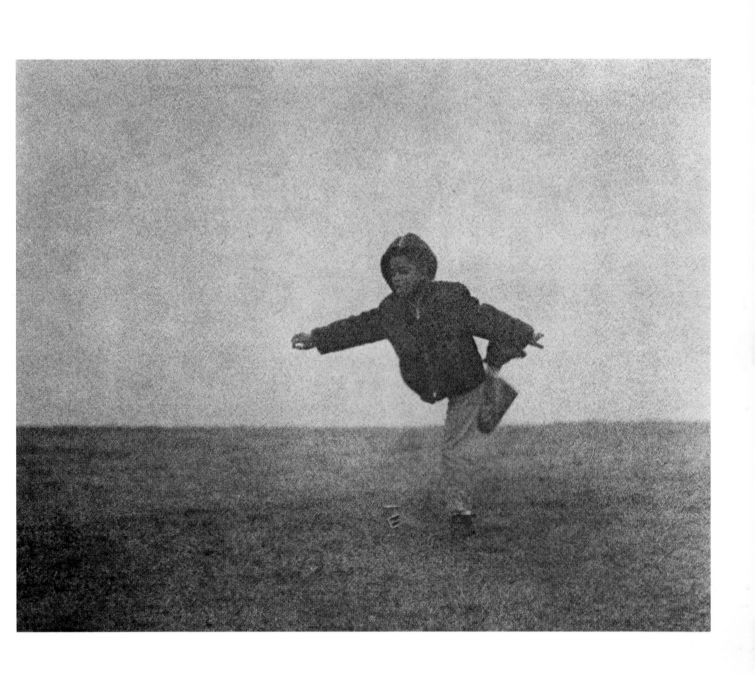

*We must provide constructive activities
for our children.
We must set a good example
for our children and teach them
to always be ready to accept the
responsibilities that are necessary for
building good communities and nations.*

Malcolm X
Founder of the Organization
of Afro American Unity

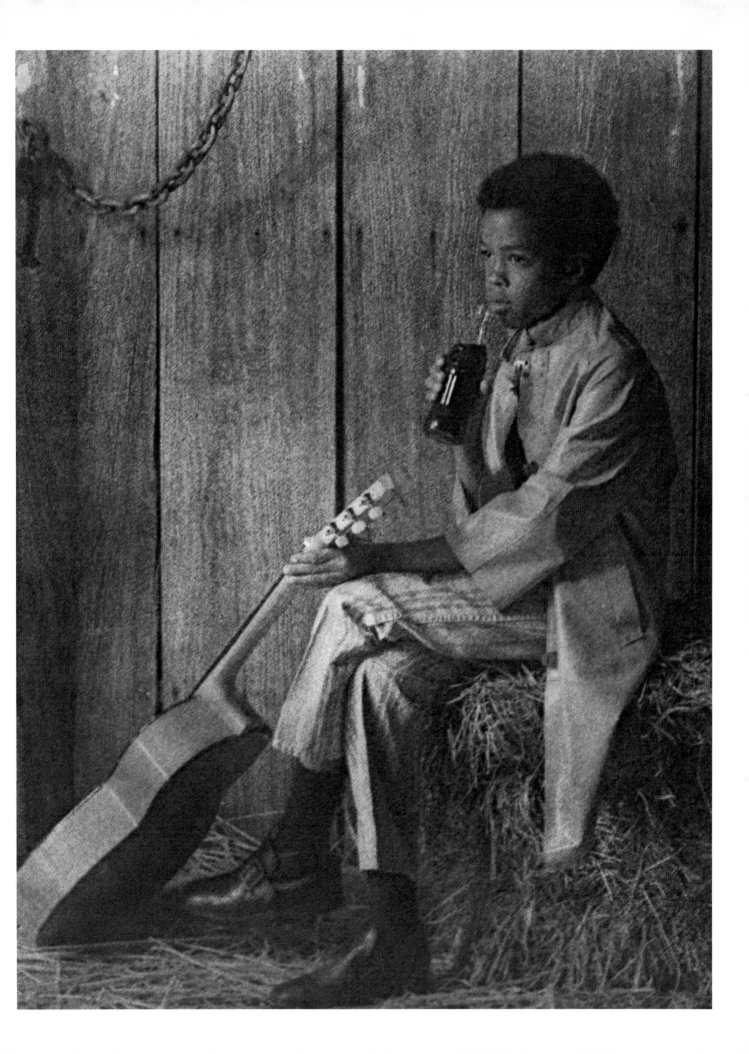

*Let's get more and more kids into our world,
and let's get into theirs.
Let us make it happen interracially
and interculturally, too, since we
have chosen America as the melting pot,
let's start it in a better direction
with our children today.*

Thomas A. Peters
Education Co-Ordinator
Child Care Conference 1971

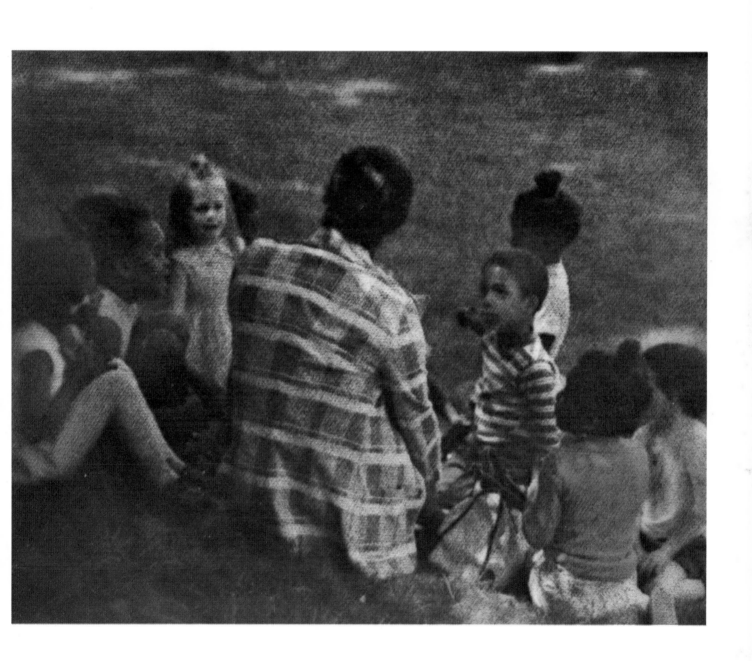

*We do not question the urgent need
to support institutions of education,
religion or health because
they cannot make their way in a marketplace.
We support them because they are basic to
our physical, spiritual and intellectual needs.
The time has long since passed
when there should be any question
about the inclusion of the arts as a
legitimate claiment upon your benefactions.*

Dr. William Schuman, President
Lincoln Center for the Performing Arts

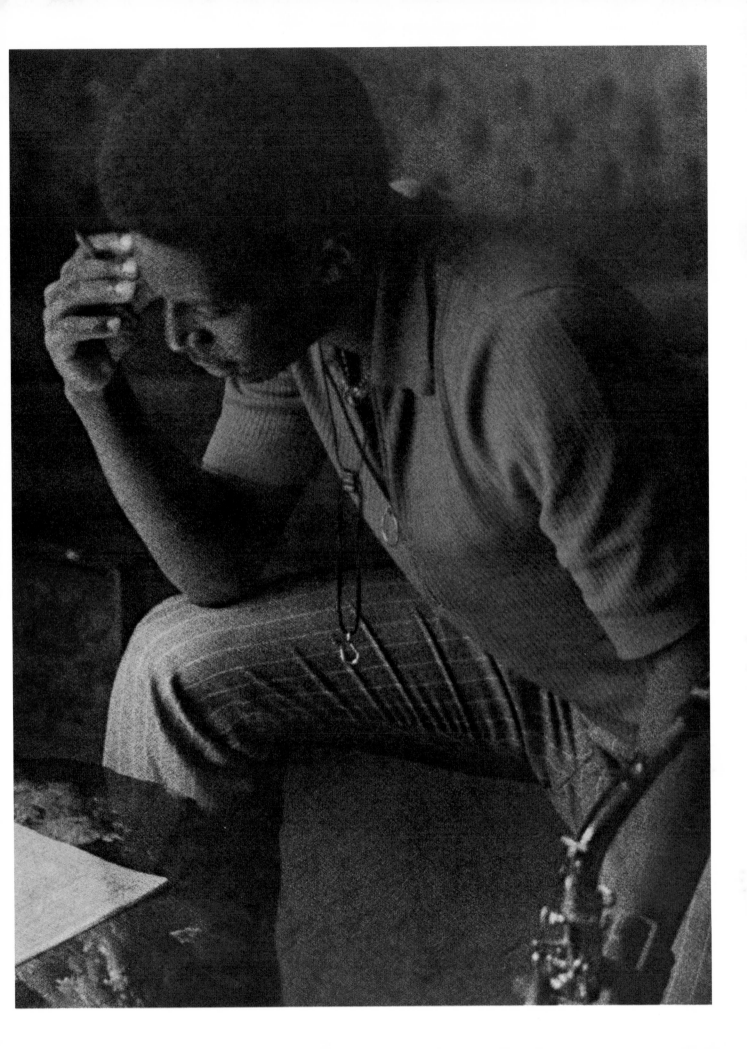

It needs no arguing that we are all faced
with the necessity of correcting
social injustice and reversing urban decay.
But as we face these problems,
we are in danger of evaluating everything
we do in their terms and
while we must spare no effort and
no expense to erase the inequities
of American life,
we must at the same time be careful
to preserve such special values
as those epitomized by the arts.

Dr. William Schuman, President
Lincoln Center for the Performing Arts

72

We love to be independent,
but we are also interdependent.
No man is an island.
We live as a family of people and when
any member of that human family
is in want, denied, abused,
the victims of injustice —
we all suffer just a little bit —
we are that much weaker.

Barbara A. Gunn, Ph.D.
Human Relations Specialist
Conference on Aging

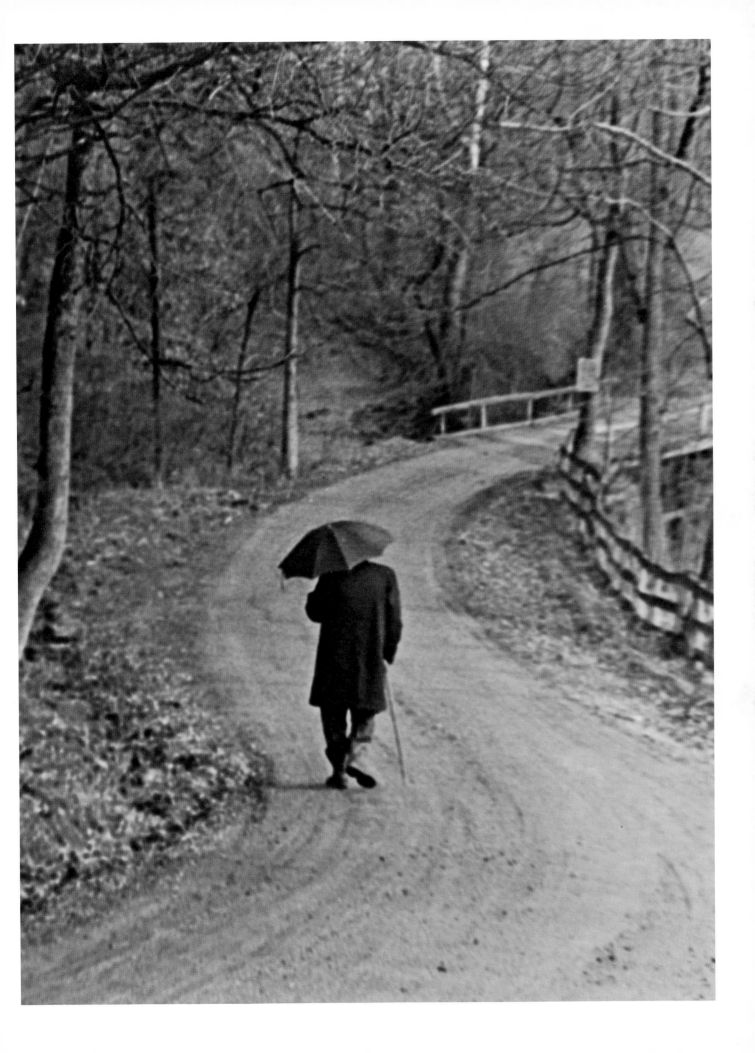

We might remember that the black movement
didn't get started in this country until
people began to believe that truly
black is beautiful and we see today
beautiful black people with their heads held high.
And as blacks truly believe
black is beautiful, then there is no need
for skin lightners and hair straightners
to make them white.
And, I would think that as
old age becomes beautiful,
old people hold their heads high —
and there is no need for
rejuvenation skin creams
and the other trappings for youth
because old age is beautiful.

Barbara A. Gunn, Ph.D.
Human Relations Specialist
Conference on Aging

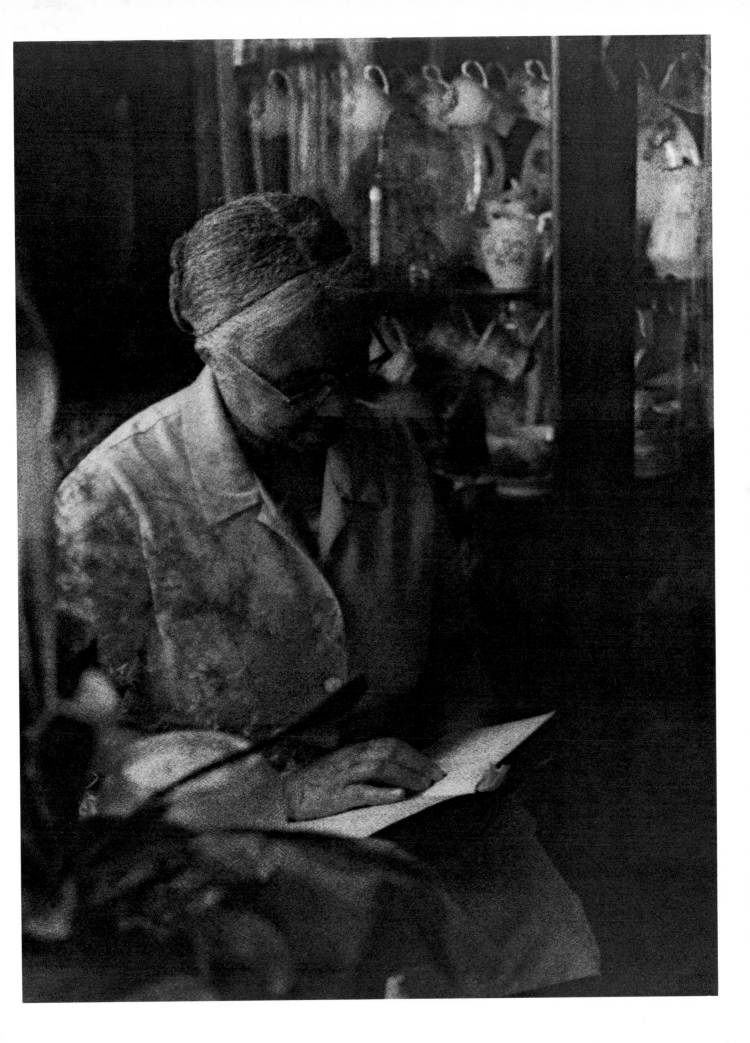

*Institutional efforts must go beyond
taking less credentialed youngsters
into their hallowed halls:
the institutions will have to offer them
special support services
after they get there
— we can't "just get rid of them"
if they start to fail.
If their intellectual foundations are weak,
then we have to do a rebuilding job.*

Harold Howe, Educator
Changing the Pecking Order

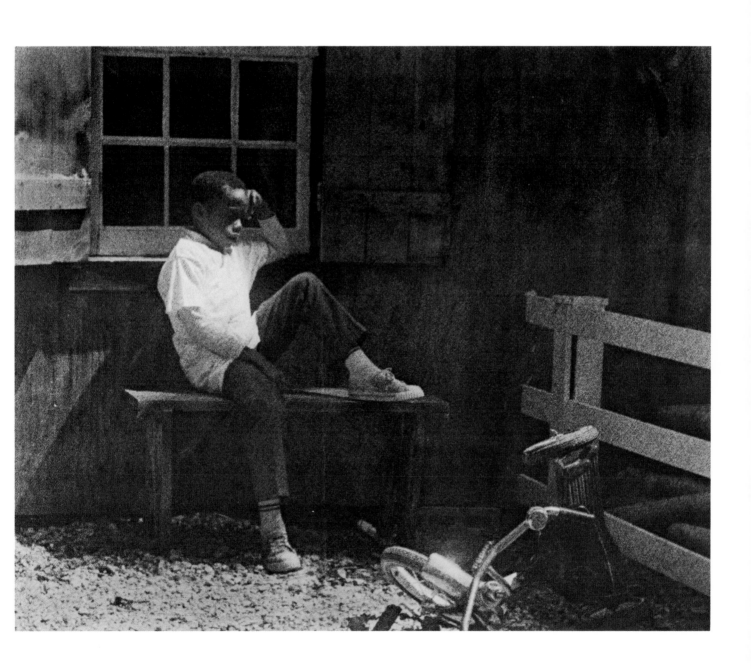

*We are constantly gaining more knowledge
of the weapons with which
to carry out our war on poverty.
Some of the approaches are associated
with the sheer alleviation of destitution,
through providing funds directly.*

The Honorable Stanley S. Surrey
Asst. Secretary of the Treasury

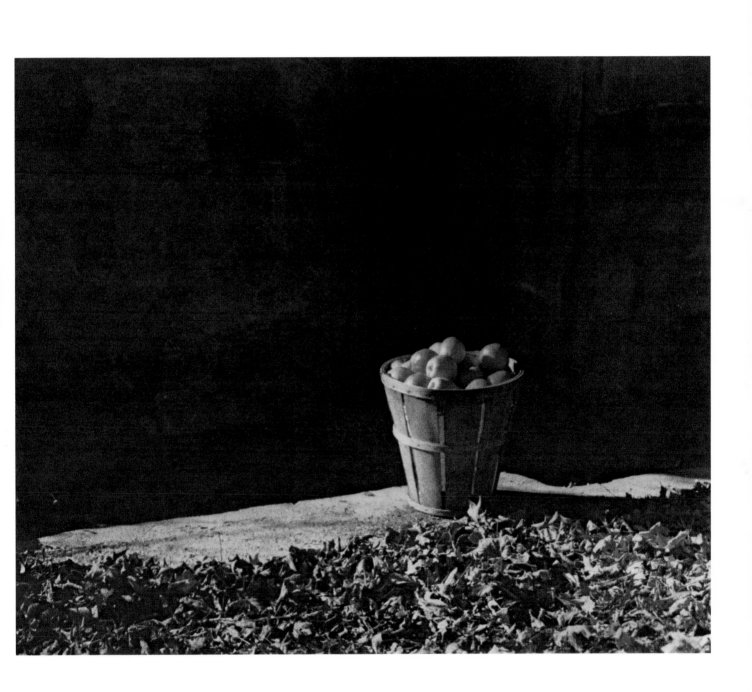

*Because I believe in the reason and
essential goodness of human beings;
because I have deep respect for and
faith in my fellow man,
I look to the future of race relations
in our country with reasonable optimism.
I know that there are very many men and women
of goodwill in the North, South,
East and West, that their ranks increase daily,
that their influence is being widely felt and
that its influence is gradually clearing away
the race-relation fog which enshrouds us.
But I must add that where rights and
birthrights are concerned, gradual progress
can never be rapid enough for those deprived,
since rights and birthrights
can never be enjoyed posthumously.*

Ralph J. Bunche
Nobel Peace Prize 1950

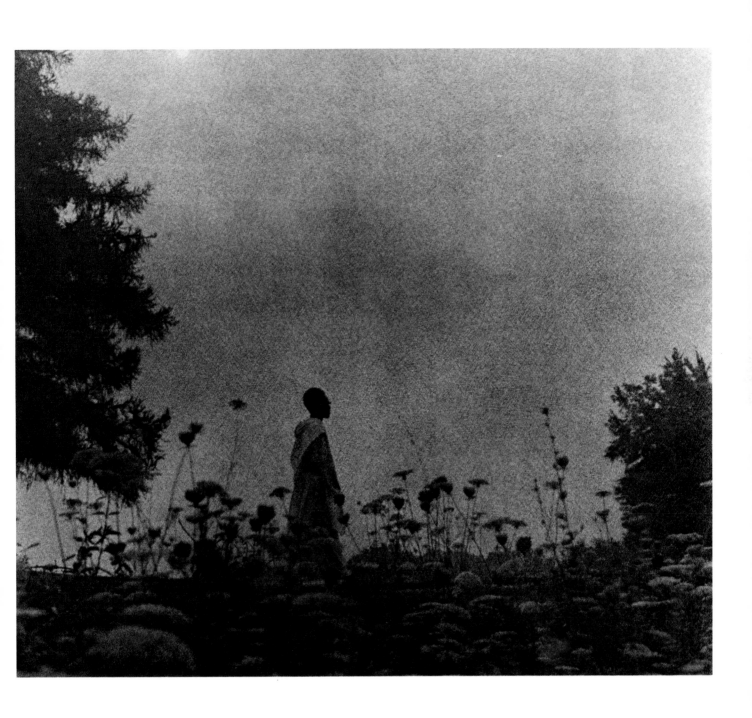

We have discovered that
every child who learns,
and every man who finds work
and every sick body that's made whole
— like a candle added to an altar —
brightens the hope of all the faithful.

Lyndon B. Johnson
President of the United States

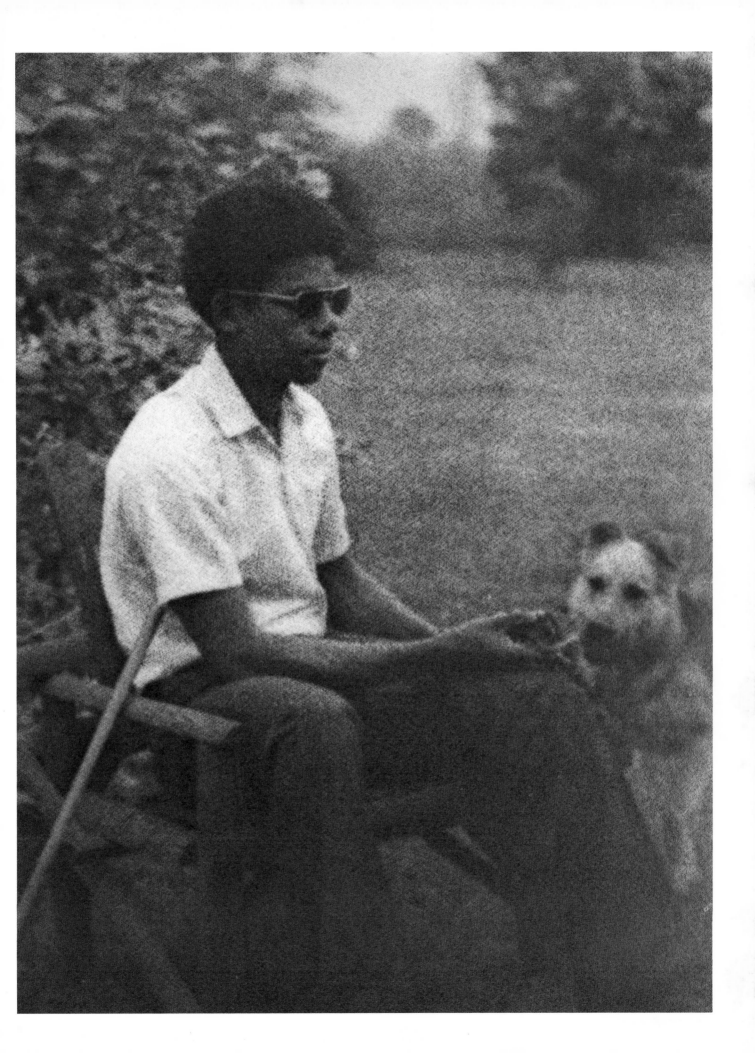

The solutions to some of our problems today are no more complex than they may have been at any point in human history.
People together, the young and the old, relating to one another, giving and taking, working and building together is the story of the human family and always will be.

Thomas A. Peters
Education Co-Ordinator
Child Care Conference 1971

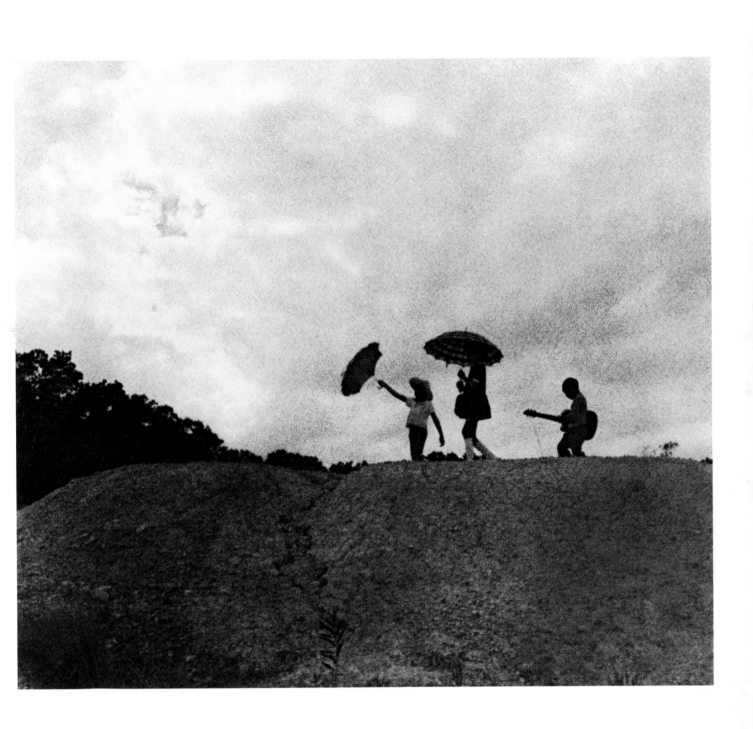

*The vitality of this great country
derives from the unity of purpose and
the devotion to its democratic ideals
of the diversified peoples
— by race, religion and national origin —
who make up its population.
Disunity and group conflict
constantly sap that vitality.*

Ralph J. Bunche
Nobel Peace Prize 1950

88

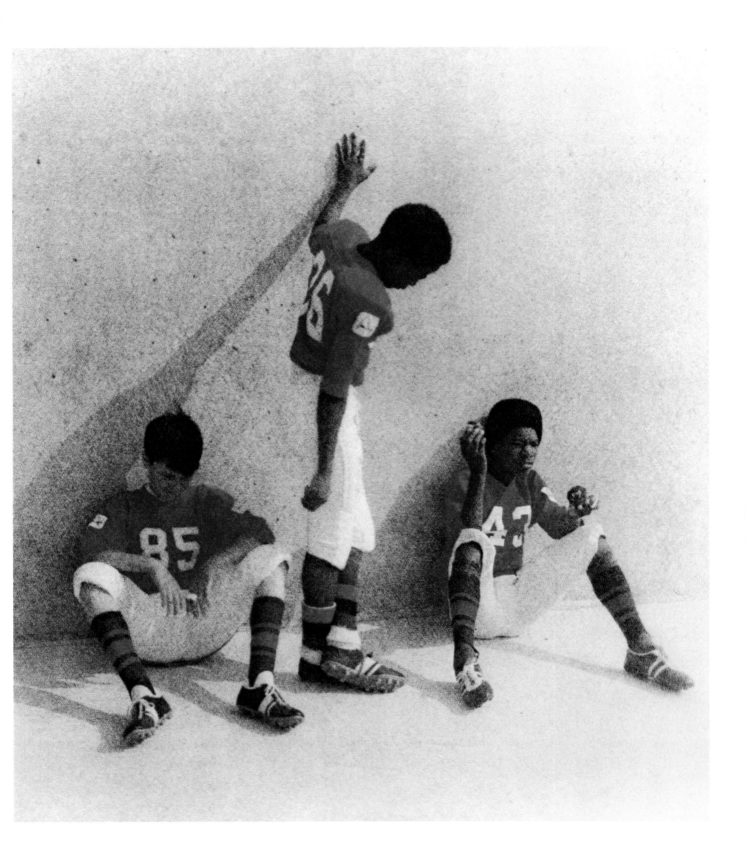

*It seems extremely important to the
survival and the health of America
that we find ways
for the institutions which control
opportunity in our society
to do so with a concern for those people who
have been denied opportunity
by the short comings of society.*

Harold Howe
Changing the Pecking Order

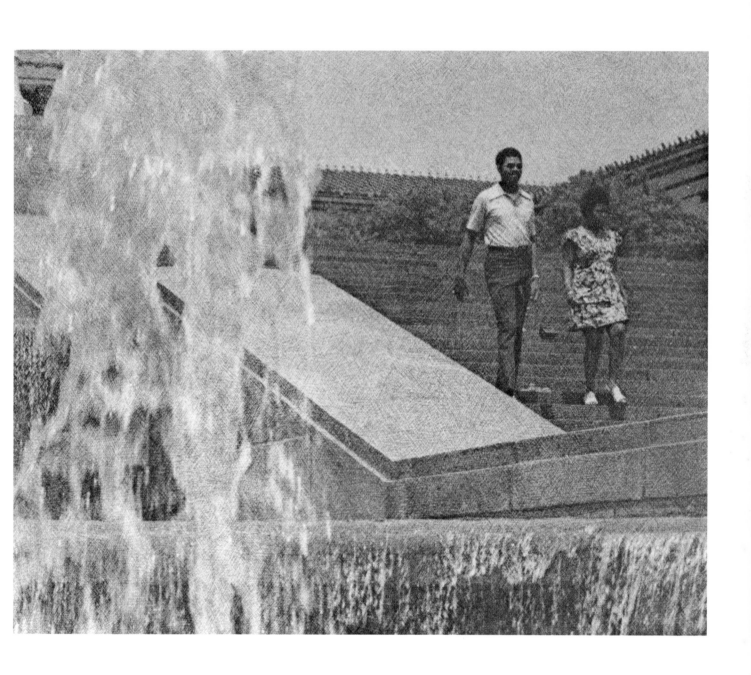

No one can speak against the backdrop
of Independence Hall without feeling
the fervent historical spirit
of our democracy and our Constitution.
Those who wrote the words
— "We hold these truths to be self-evident,
that all men are created equal . . . —
were engaged, during an embattled hour
of world history, in a struggle to
defend the rights of man.

Jacob Javits
United States Senator
State of New York

This practice of failing to make use of talents possessed by some individuals represents a tremendous loss of human resources to our country. Throughout the history of mankind every society has advanced literally on the backs of the down trodden who possessed the needed talents and skills.

Frederick A. Rodgers, Educator
Dream Deferred

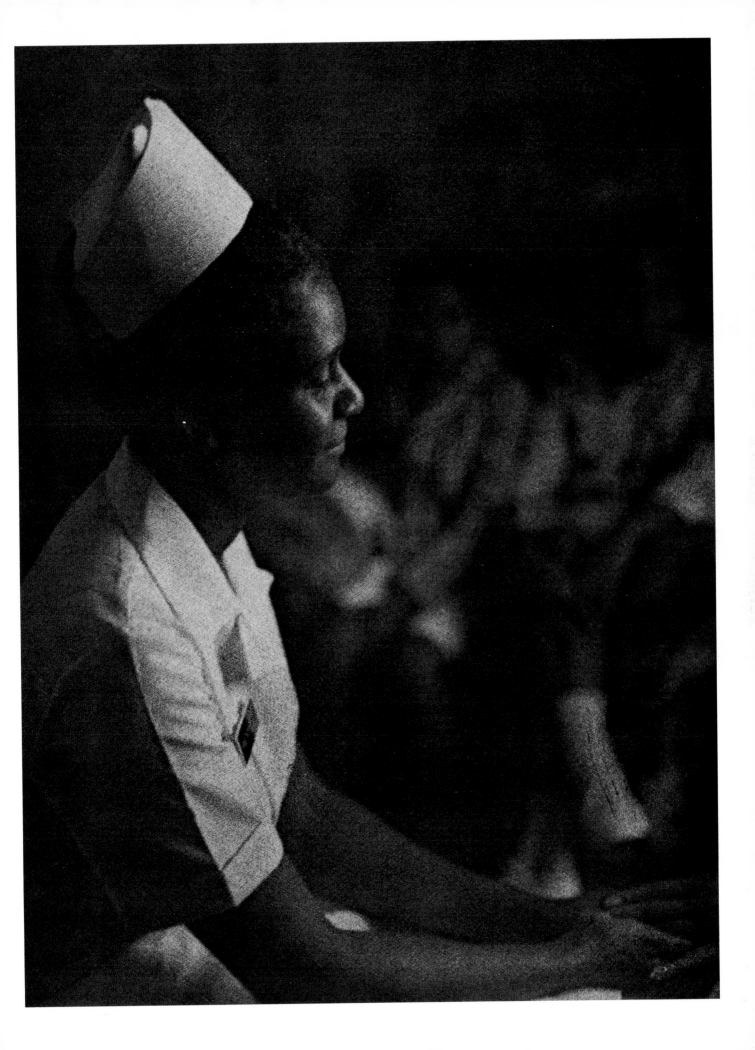

*If you provide the opportunity to work and
to learn to members of this group
and sufficient rewards for doing so,
history tells us that
they are likely to find solutions
to many of our present social problems.*

Frederick A. Rodgers, Educator
Dream Deferred

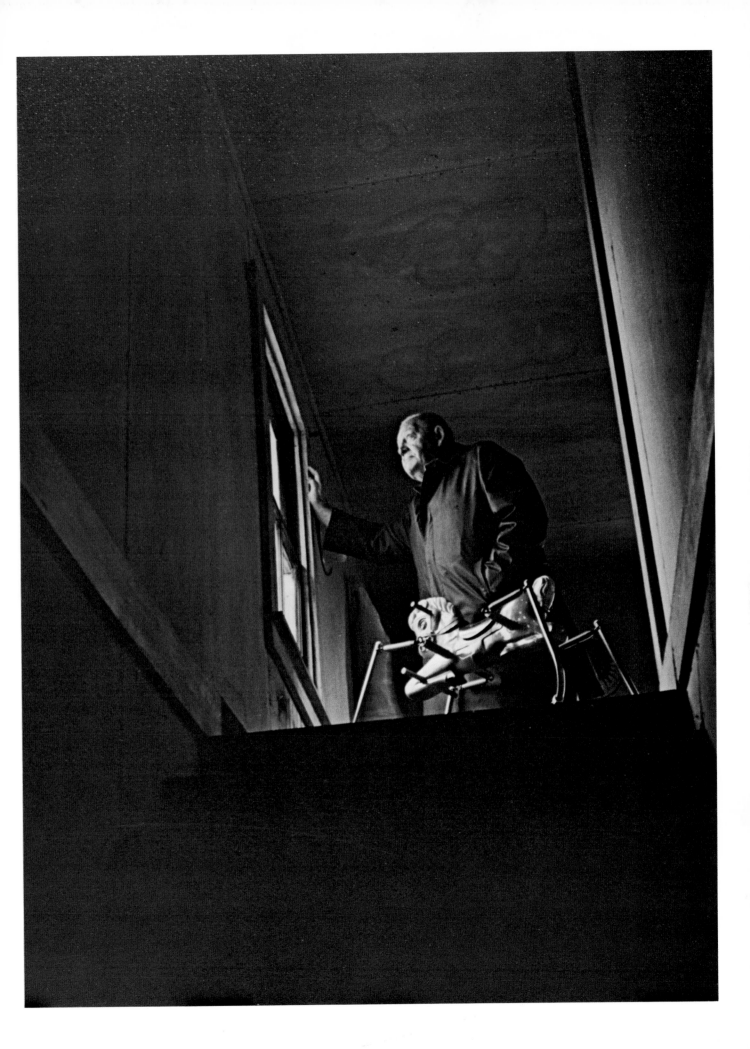

So let me say to every Negro in this country;
you must register, you must vote,
you must learn so your choices
advance your interest and
the interest of our beloved nation.

Your future and your children's future
depend upon it and I don't believe
you're going to let them down.

Lyndon B. Johnson, President
United States

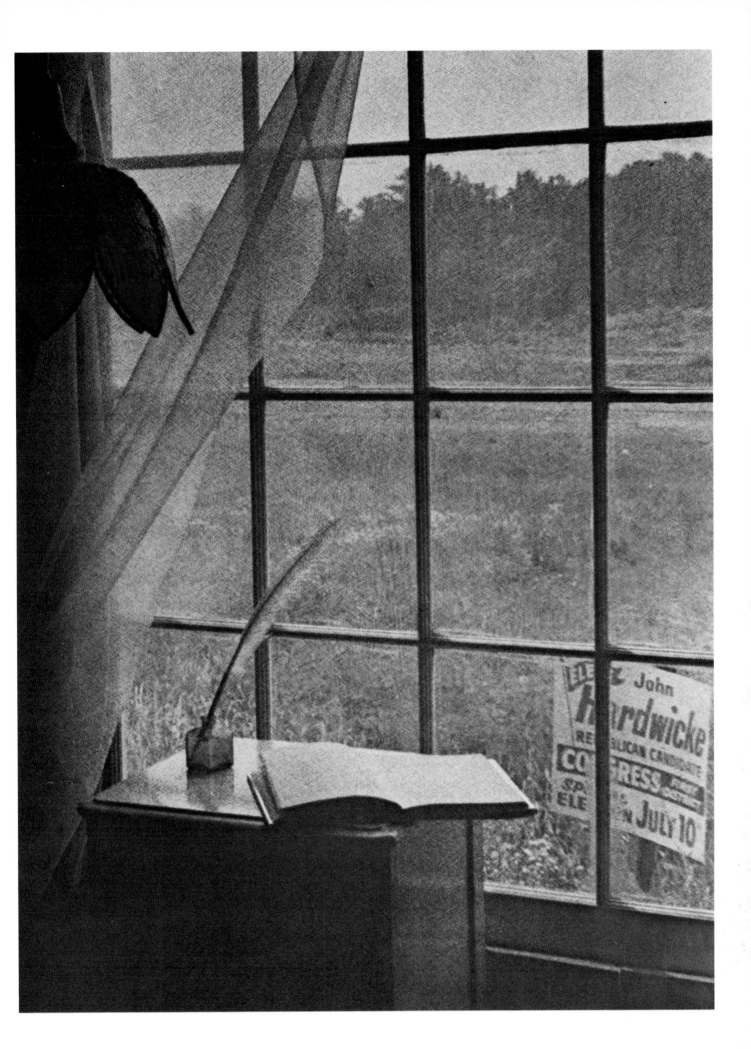

*In a vital society the citizen has a role
that goes beyond the duties at the ballot box.
He must man the party machinery,
support social and civic reform,
provide adequate funds, criticize, demand,
expose corruption and honor leaders who lead.*

John W. Gardner, Secretary
Health, Education and Welfare

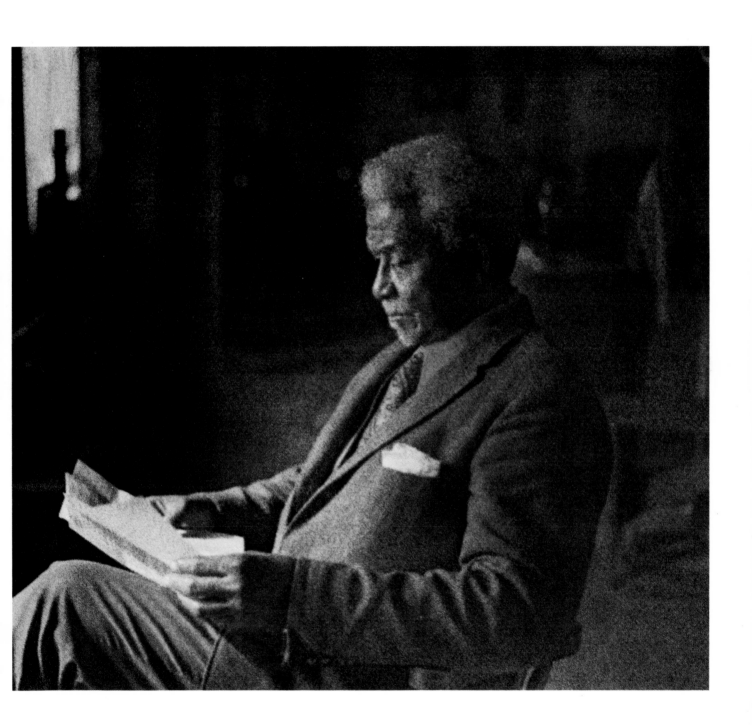

Our children, yours and mine,
in every school across the land,
every morning pledge allegiance to the flag
of the United States and to the
republic for which it stands and then,
they, the children, speak fervently and
innocently of this land as the land of
"liberty and justice for all."

The time, I believe, has come to work together
— for it is not enough to hope together,
and it is not enough to pray together —
to work together that this children's oath,
pronounced every morning from Maine to
California, from North to South,
that this oath will become a glorious,
unshakable reality in a morally renewed
and united America.

Rabbi Joachim
Prinz National President
American Jewish Congress

102

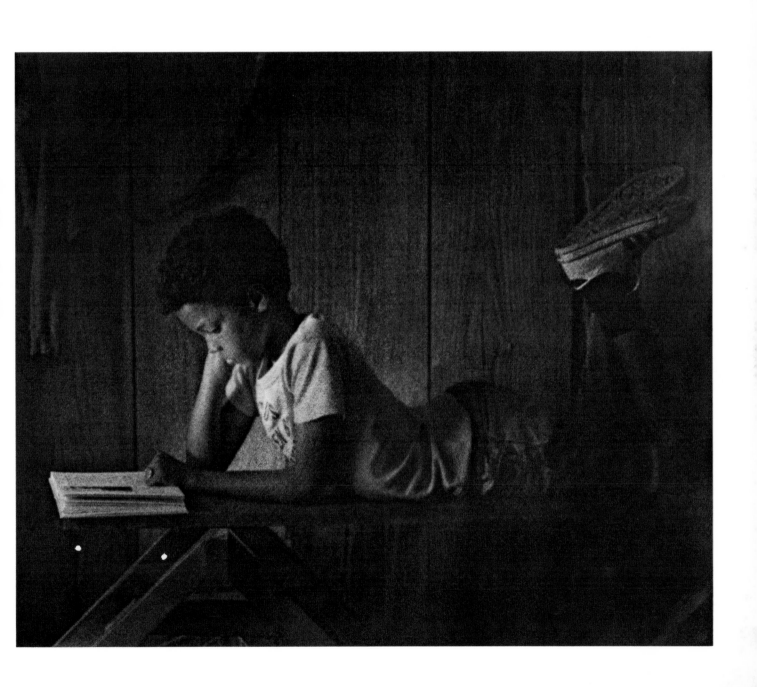

*Nothing matters more to the quality
of our lives than the way we treat one another,
than the capacity to live
respectfully together as a unified society,
with a full and generous regard
for the rights of others and
the feelings of others.*

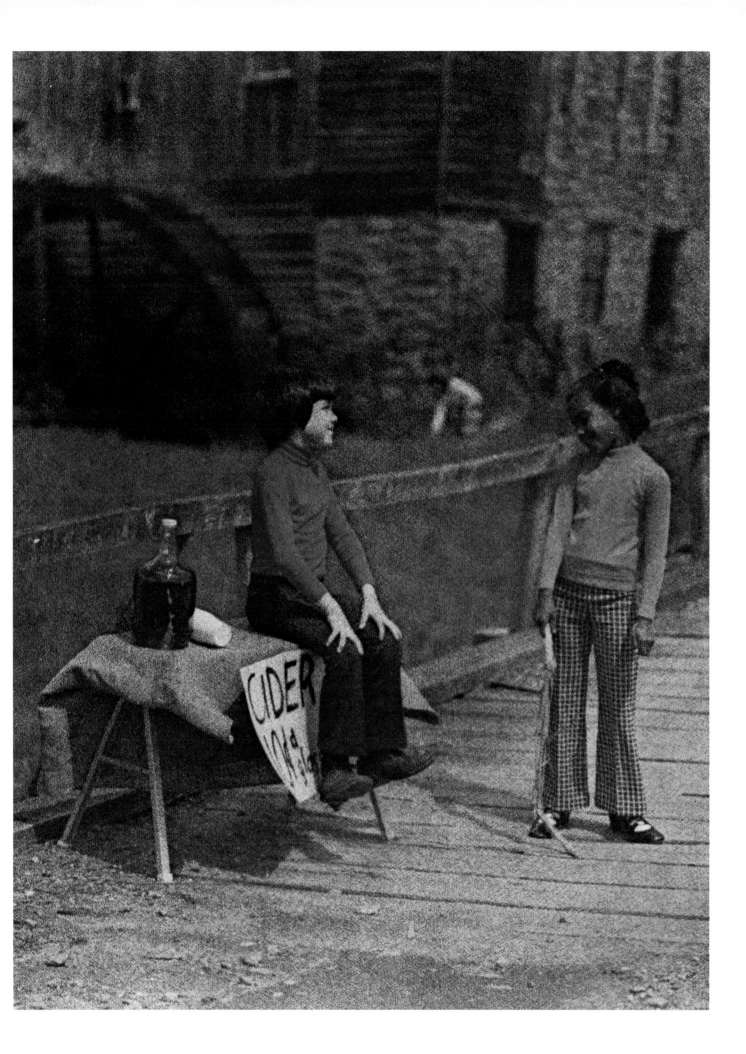

Imagine making such a fuss over
such an objectively meaningless datum
as the color of a man's skin!
Any extra terrestrial life endowed with
the most elementary intelligence
would stand appalled and baffled
by the immense delusions woven by humans
out of this gossamer thread.

Joel Kovel
Author *White Racism*

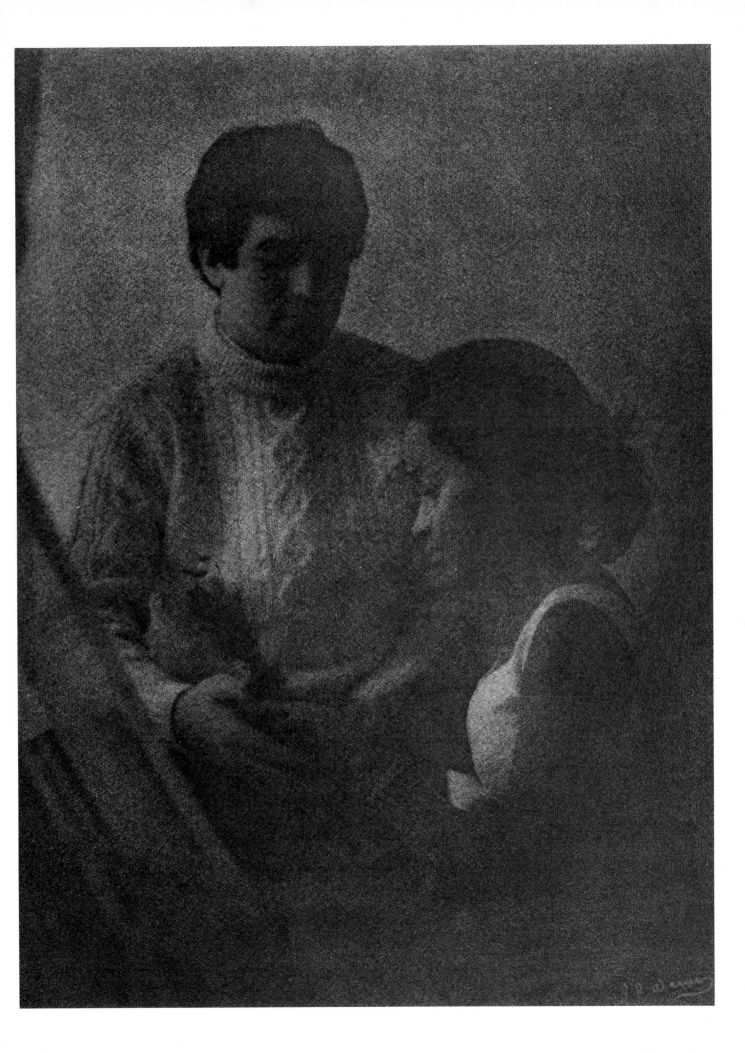

Plant next to prejudice,
another tree that grows so big
and high that discrimination
has to wither and die.

Jesse Owens
Author *Blackthink*

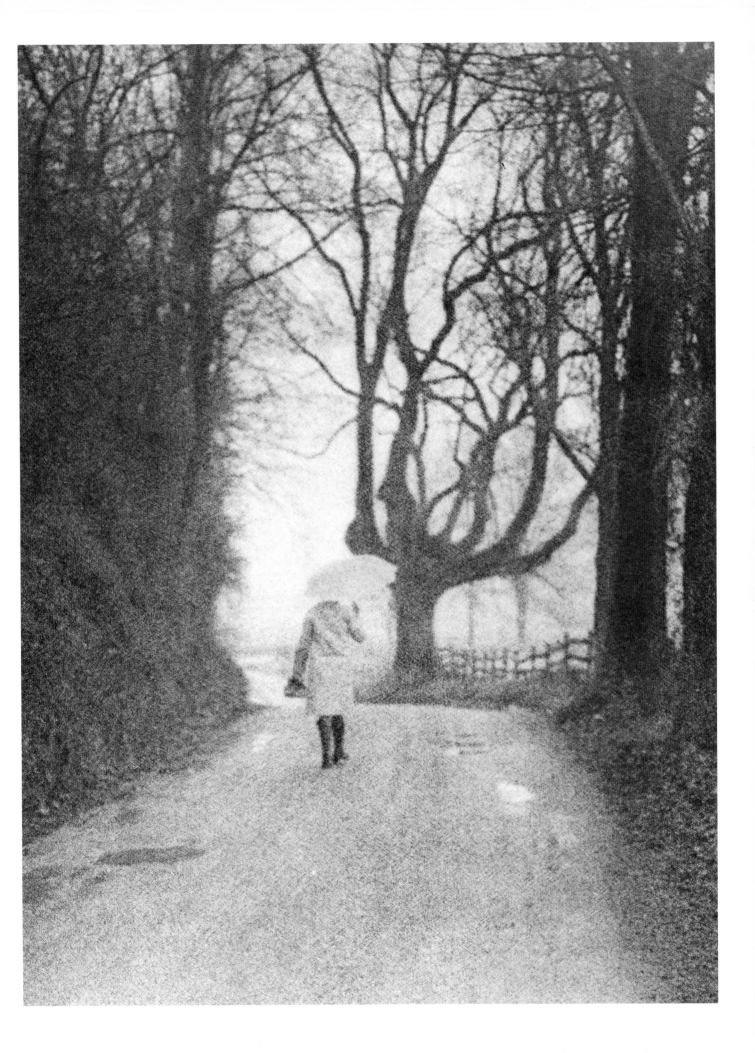

Yesterday's voices spoke in whispered,
often pleading tones.
Today's voices ring out loud
and clear and proud,
stating opinions and delivering messages
of hope, fear, despair and truth.

Talmadge Spratt

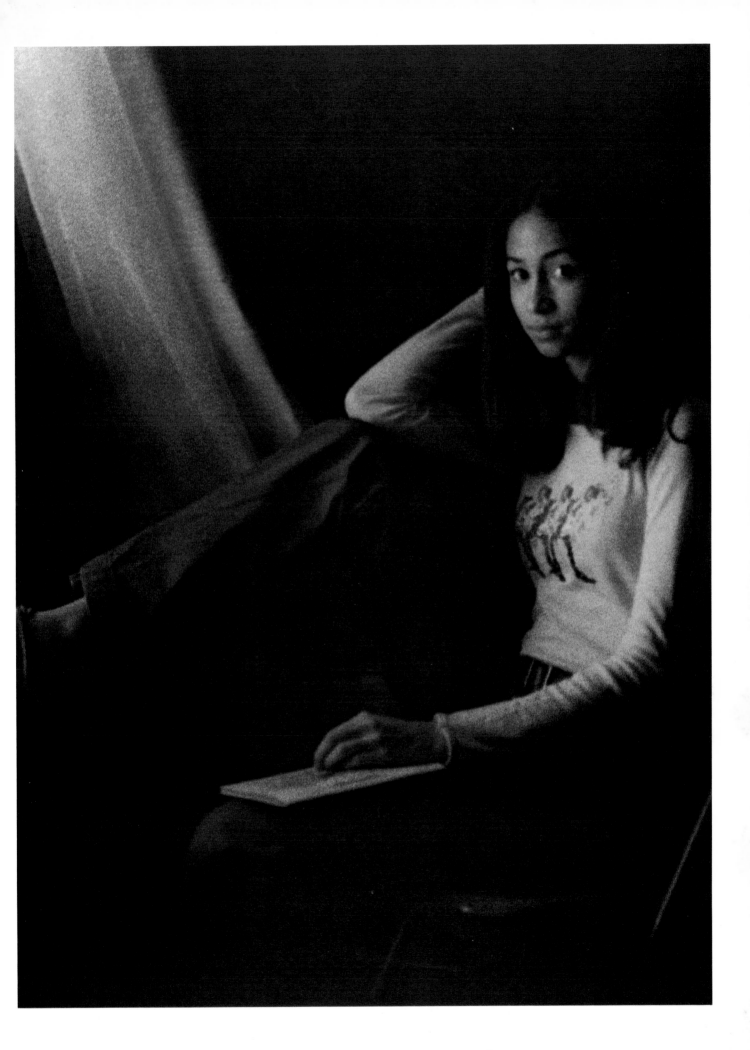

What I want
What I am
What you force me to be is
What you are
For I am you,
staring back from a mirror.

Gordon Parks
Author *Born Black*

112

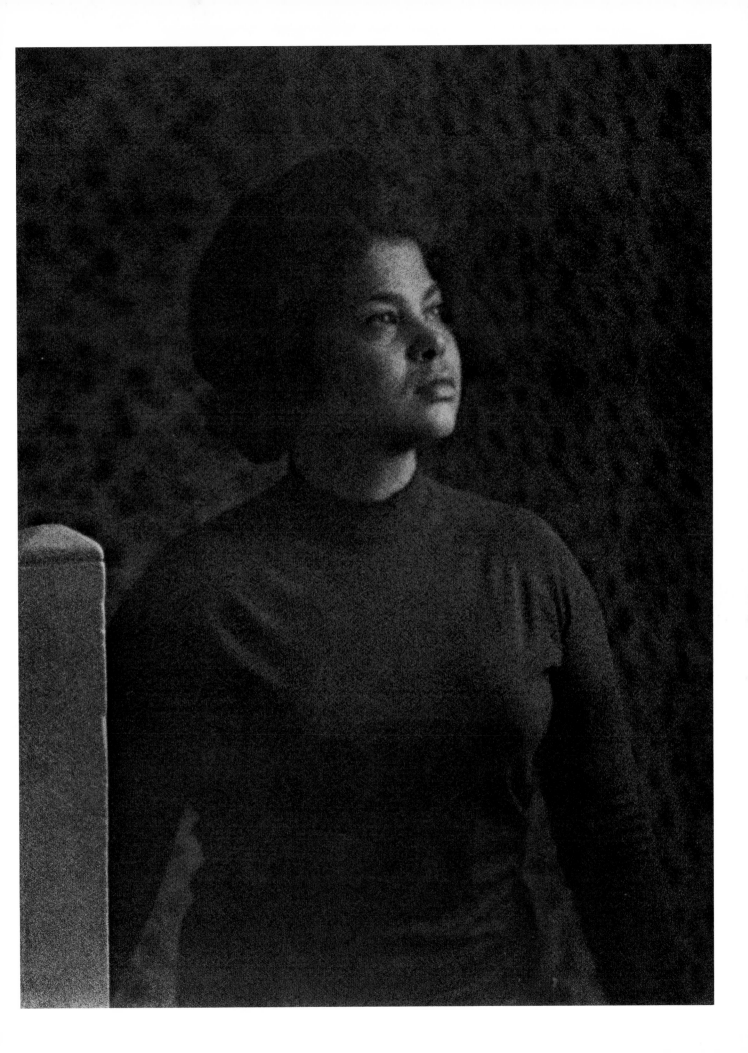

We are not as far apart as it might seem.
There is something about both of us
that goes deeper than blood
or black or white.
It is our common search for a
better life, a better world.

Gordon Parks
Author ***Born Black***

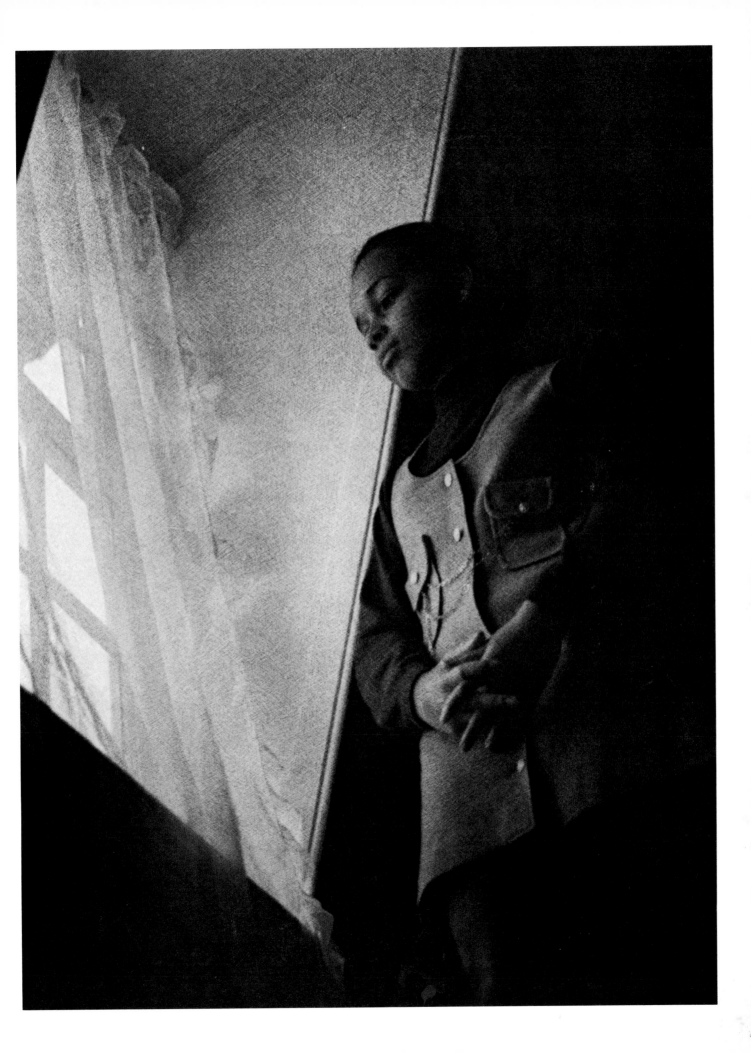

*I march now over the same ground
you once marched. I fight for the
same things you still fight for.
My children's needs are the same
as your children's. I too am America.
America is me.
It gave me the only life I know
— so I must share in its struggle
against your racism.
There is yet a chance for us to live
in peace beneath these restless skies.*

Gordon Parks
Author *Born Black*

116

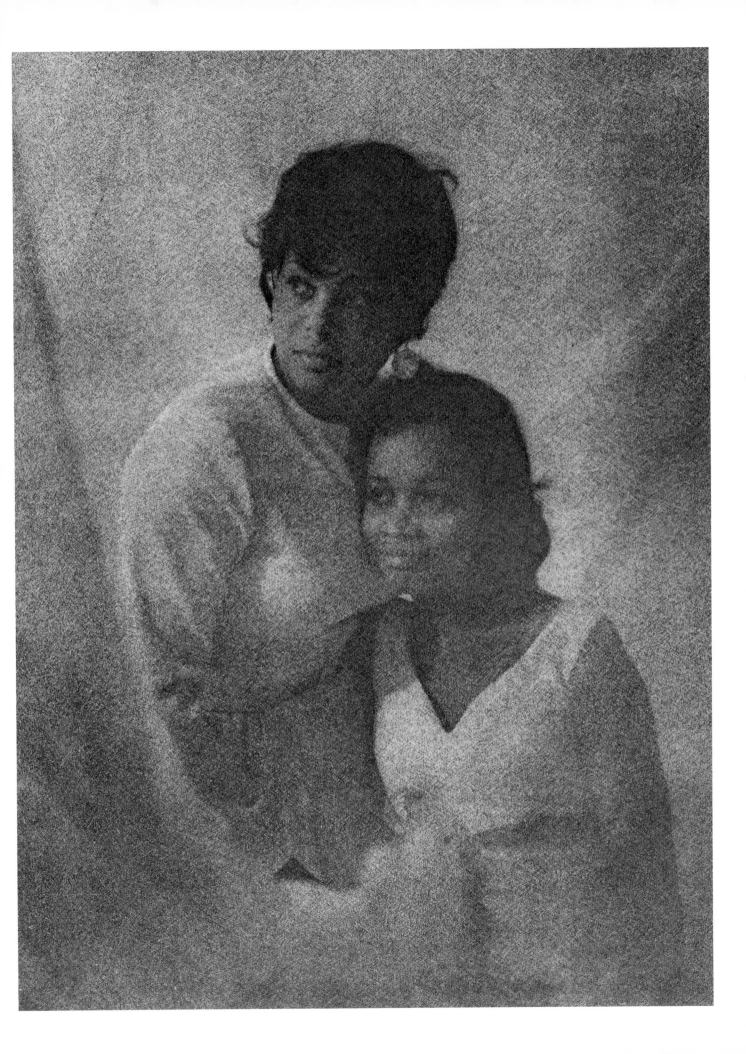

The black man's responsibility today
is to establish his own values
and his own goals.
In doing so, he also will be
affecting the larger American society
of which he is a part.
The black man and the black woman
cannot, however, act alone.
They must act within an everwidening
community of family, university,
job and neighborhood.
As each of these "communities" affect the
individual, so will the
individual affect his environment.
You, as individuals, have that choice.
You cannot substitute "honky" for "nigger"
and hate for love.

C. Payne Lucas
Peace Corps.

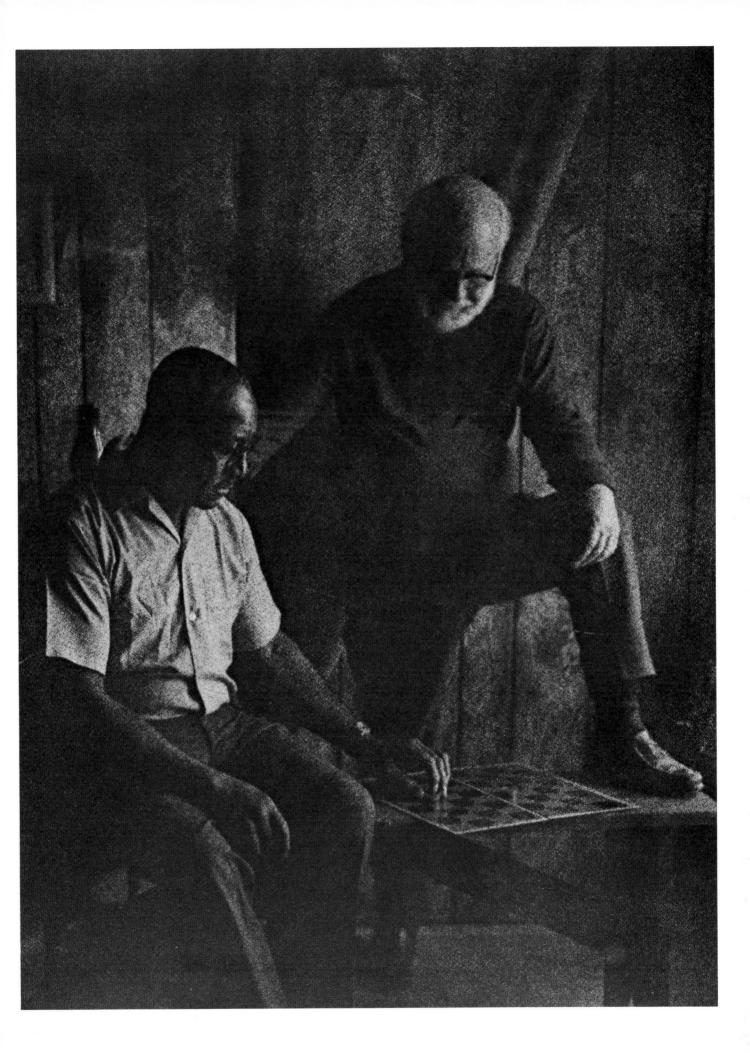

Tolerance, patience, humaneness and a gentle
untiring hand will be essential to avoid division.
Too, we must create ways for
the exchange of views among all of our people.
Agencies of criminal justice must be fair and
effective if they are to hold us together
in the turbulence of the years ahead
until we have removed the underlying
causes of crime in America.
Our laws must provide moral leadership and
cannot therefore themselves be immoral.
Our purpose as a people must have a clear
and generous meaning of equality for all.
We must strive to fulfill the obligations
of a great nation, to achieve needed reforms,
to offer fulfillment,
human dignity and reverence for life.

Ramsey Clark
Attorney General U.S.

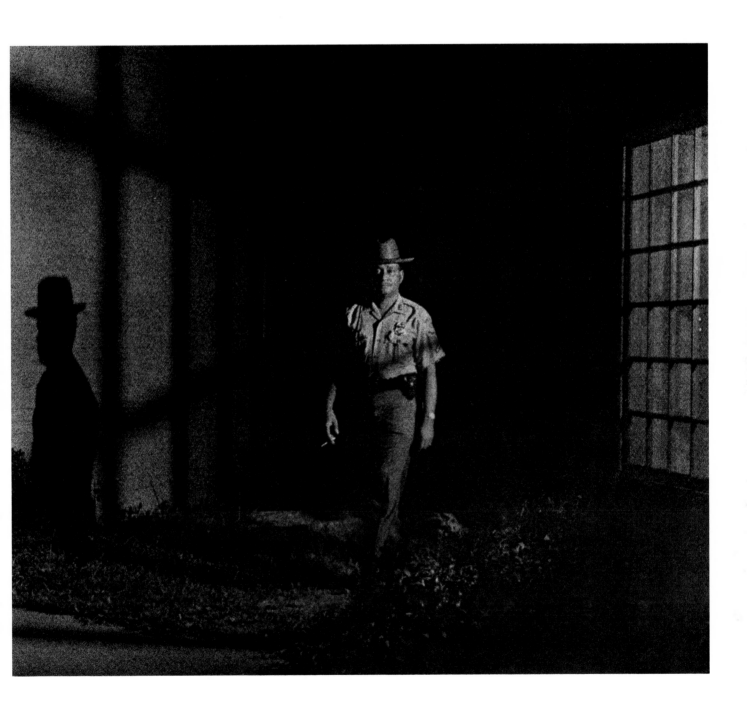

Love builds.
It is positive and helpful.
It is more beneficial than hate.
Injuries quickly forgotten
quickly pass away.

Mary McLeod Bethune, Ph.D.
American Educator

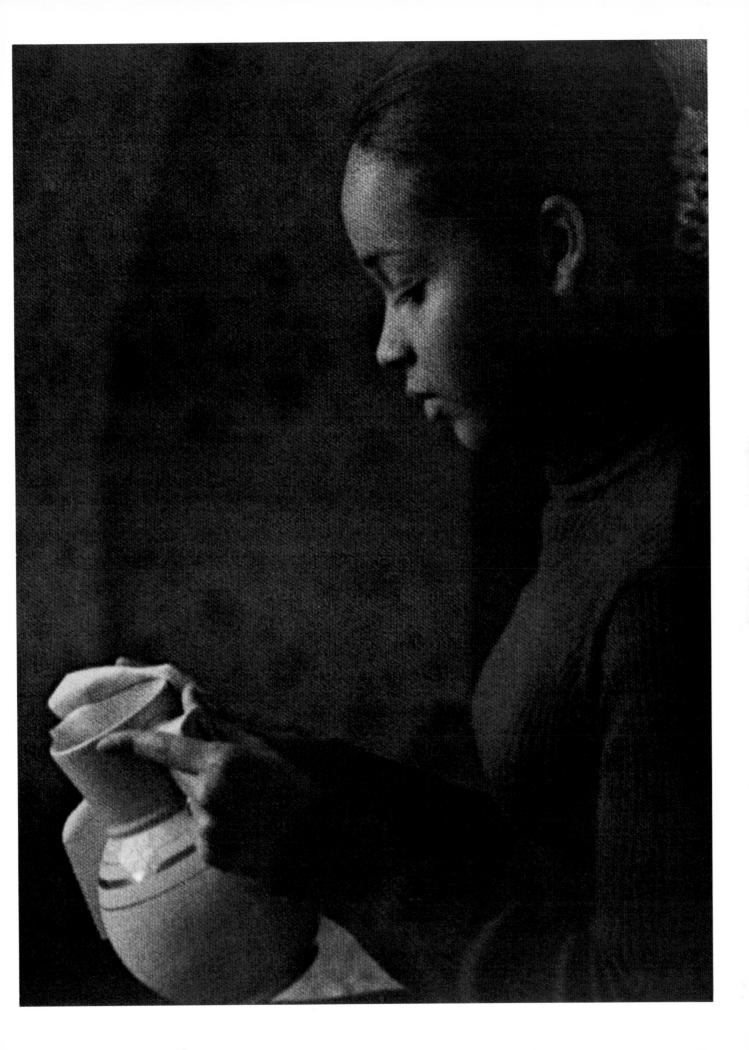

*"Love Thy Neighbor" is a precept
which could transform the world
if it were universally practiced.*

*It connotes brotherhood,
and to me brotherhood of man
is the noblest concept
in all human relations.
Loving your neighbor means being
interracial, interreligious, and international.*

Mary McLeod Bethune, Ph.D.
American Educator

124

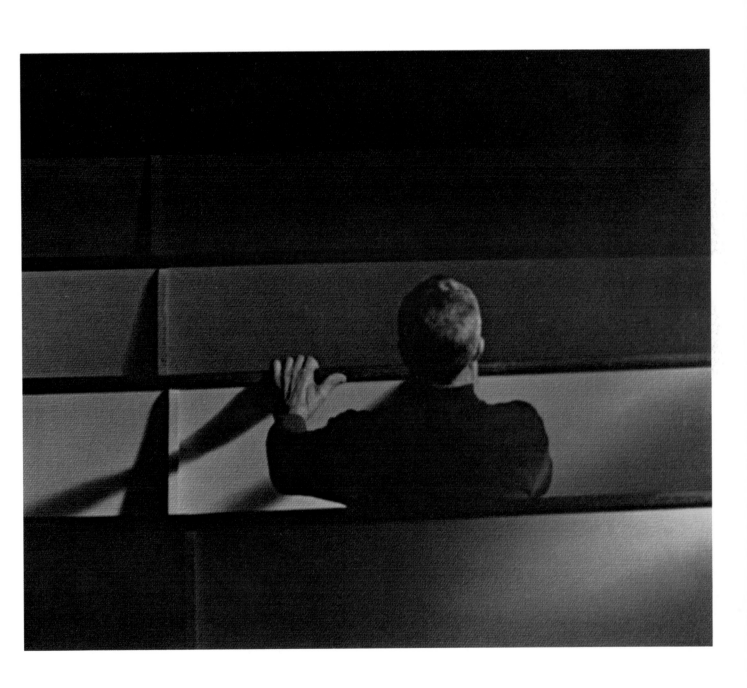

We can upgrade the people who work for us.
We must — if not on moral grounds to preserve
and promote "The American Dream,"
then because business, government, education
(all sectors of our economy)
cannot meet the ever increasing needs
of society without utilizing the
full potential of all our people.
Facing a critical shortage of manpower,
we cannot afford to overlook the
enormous pool of talent right in our very midst,
in the under-utilized, over qualified Negro.

Alexander N. McFarlane

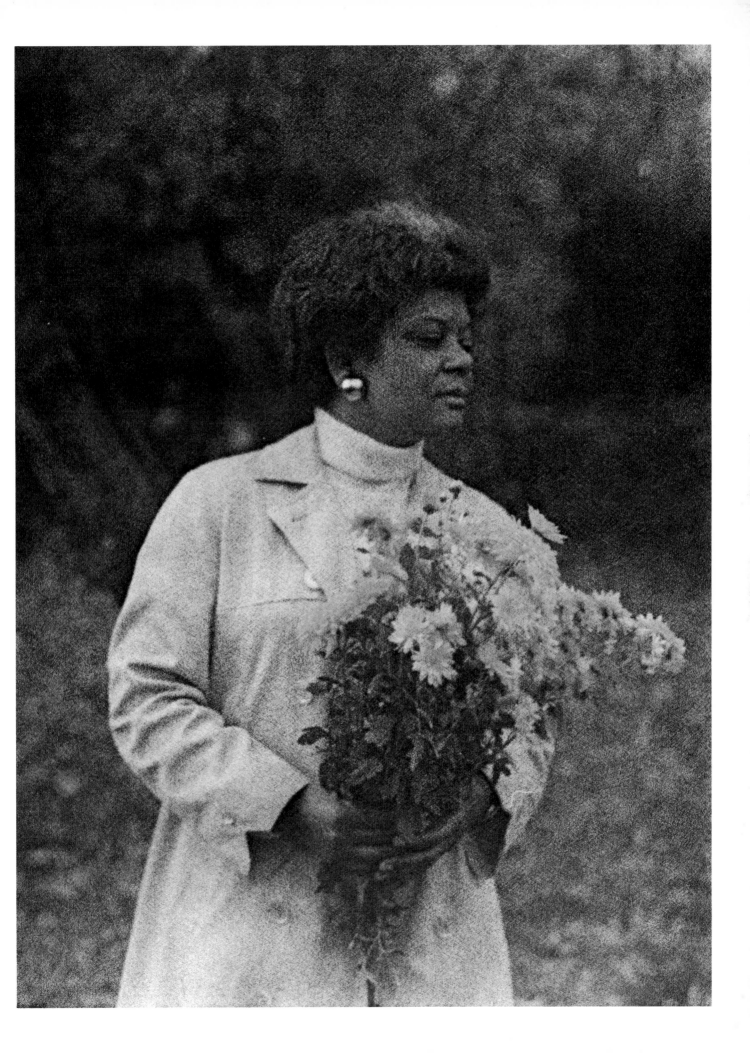

If we are honestly concerned about
the quality of urban life,
we must look not only at
Harlem and Hough and Lawndale,
but also at our Park Avenues,
our Lake Shore Drives and our Wilshire Blvds.
These are the streets of white Americans
— affluent, defensive and uncertain
whether to stay in the city,
or to rush to the suburbs
to the same problems there,
for there is no longer
any escape for those who run.

John V. Lindsay
Mayor of New York

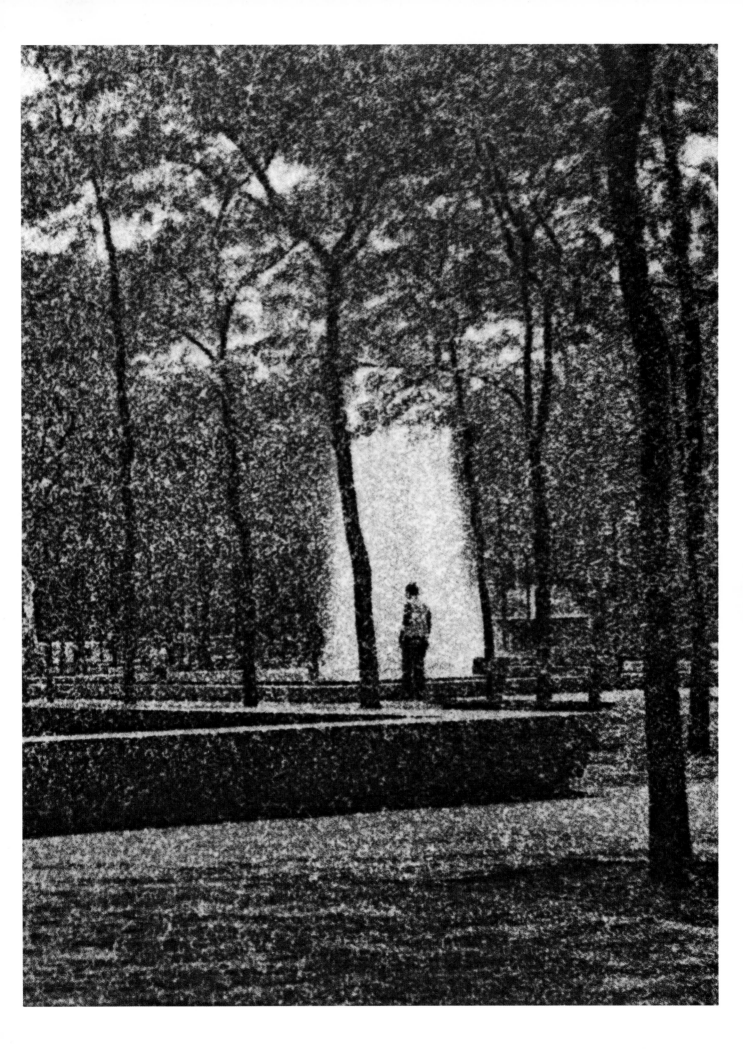

Color is just color.
It is a physical, a spectroscopic fact.
It carries no compellingly deducible
conclusions regarding a person's beliefs
or his position in any social structure.
Color is not acquired or possessed
by leading a good or bad life.
No intentions of the world are inherent in it;
no attachments are constituted by it.
The mind is not at work in it,
and it is not a social relationship.
It is inherently meaningless.

Edward Shils, Author

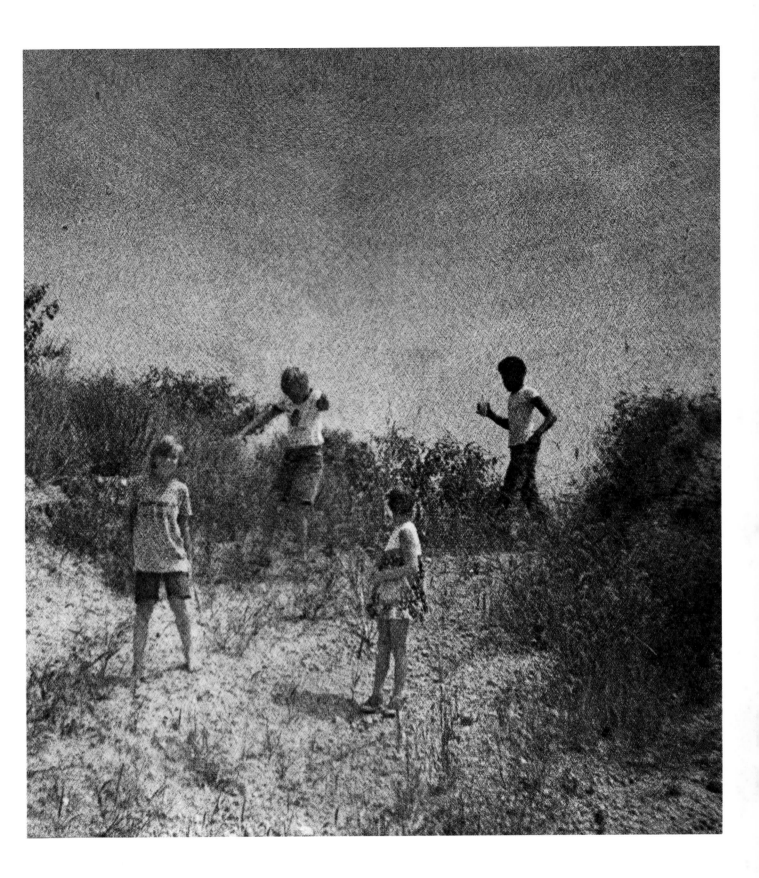

*In different parts of the world and
in different eras many different groups
of people have supplied scapegoats
to those they live among.
The physical differences between the races
provide those who need scapegoats
better material to work with
because such differences are
readily visible and permanent.*

Robert Froman
Author *Racism*

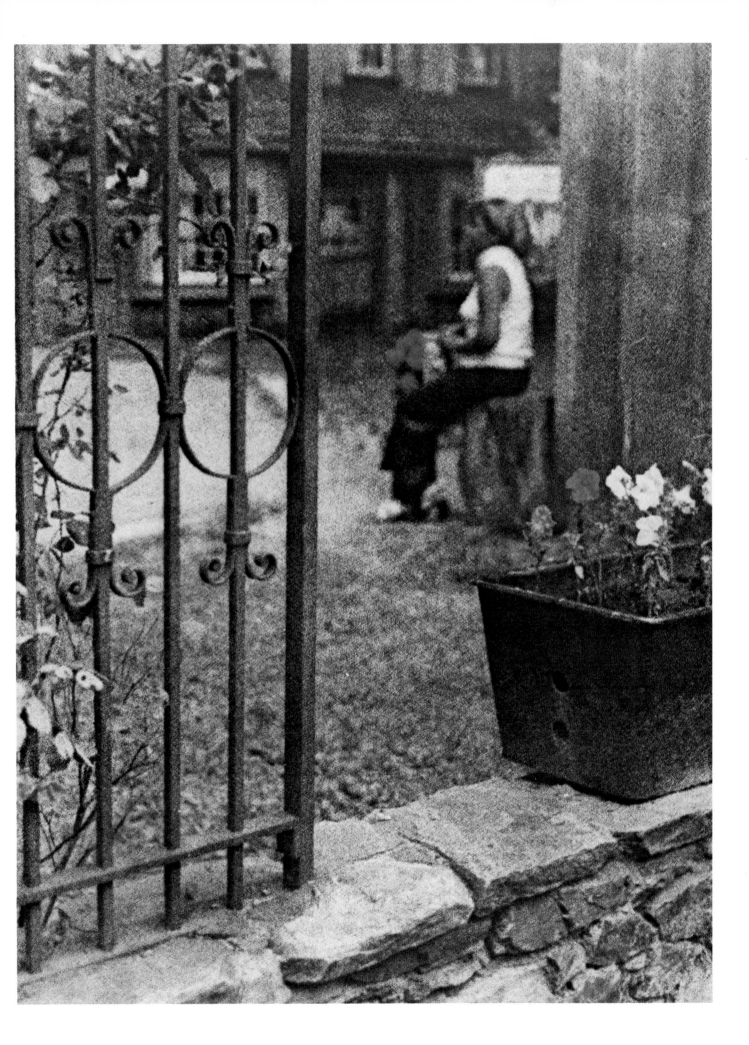

Raise them to do the right thing,
to be able to take care of themselves
and be prepared to face
the challenges of life as adults.

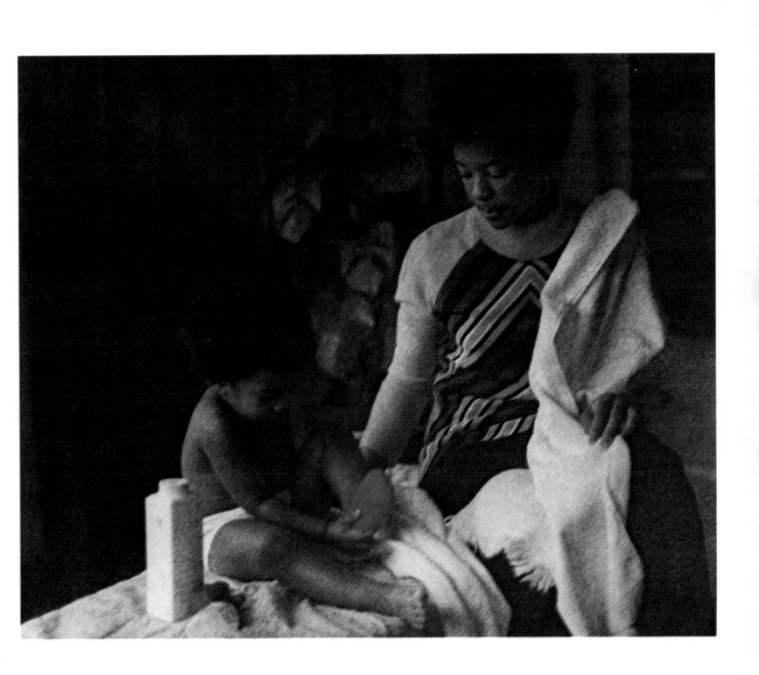

We must reject separatism from whatever source.
We must reject white separatism.
We must reject black separatism.
We must hold true to the course
on which we have embarked
— the course which leads to an
integrated society of magnificent pluralism.

Edward W. Brooke
United States Senator
State of Massachusetts

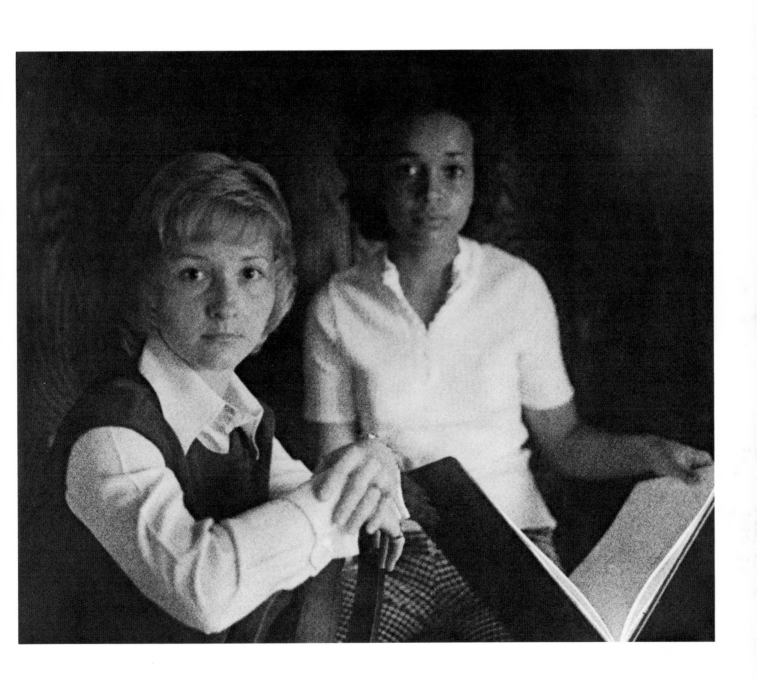

Many people get to a detour in the road
and think that's the end of the road entirely.
They toss it in, give up.
Folks, there's always an arrow there.
It shows where the detour goes,
and if you follow,
you'll eventually get back on your course.
Going a bit out of the way shouldn't disturb you.
Even backing up sometimes is necessary.
There's an art in knowing
when to back up and when to detour.
The essential thing is the faith
that you will make it eventually.
The alternative is plunging off
the bridge that isn't there.

Pearl Bailey
Author *Talking to Myself*

138

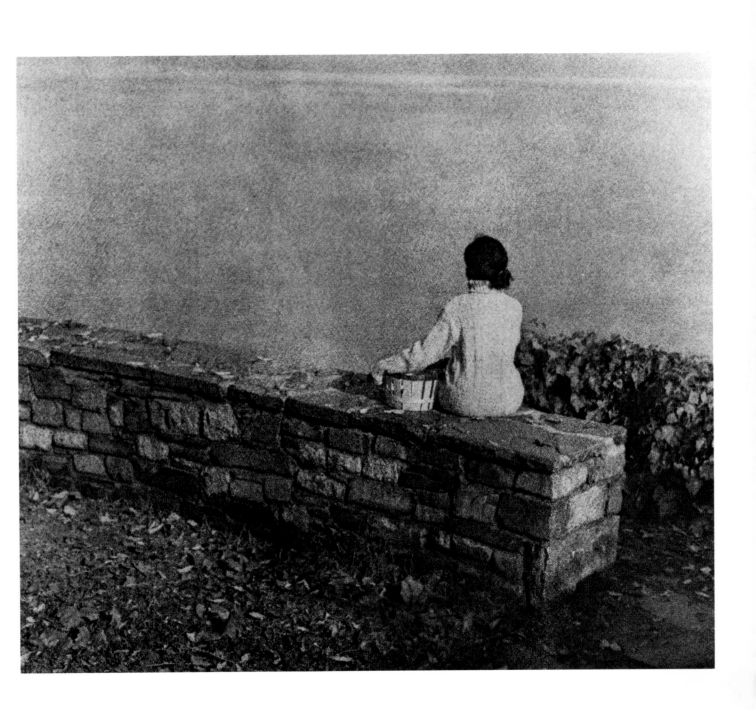

*The Negro's growth will be great
in the years to come.
Yesterday, our ancestors endured the
degradation of slavery,
yet they retained their dignity.
Today, we direct our economic and
political strength toward winning a
more abundant and secure life.
Tomorrow, a new Negro,
unhindered by race taboos and shackles,
will benefit from more than
three hundred and thirty years
of ceaseless striving and struggle.
Theirs will be a better world.*

Mary McLeod Bethune, Ph.D.
American Educator

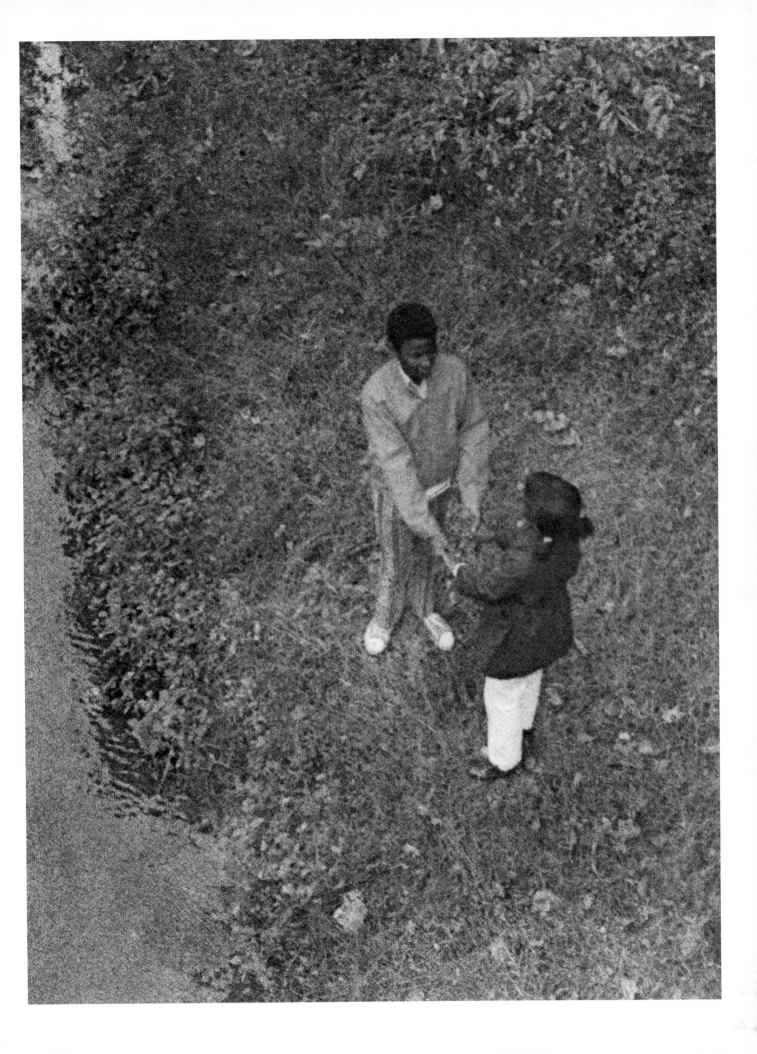

Don't hesitate to go woodshedding
with your children, if they need it.
If you don't do it, when they are young,
they'll do it to you when they are older.
Temporarily they may learn to resent you.
Take the brunt of that.
They will learn to respect you later.
Not only that but they will respect others.
It's up to you to help your kids
learn to walk among men.

Pearl Bailey
Author *Talking to Myself*

142

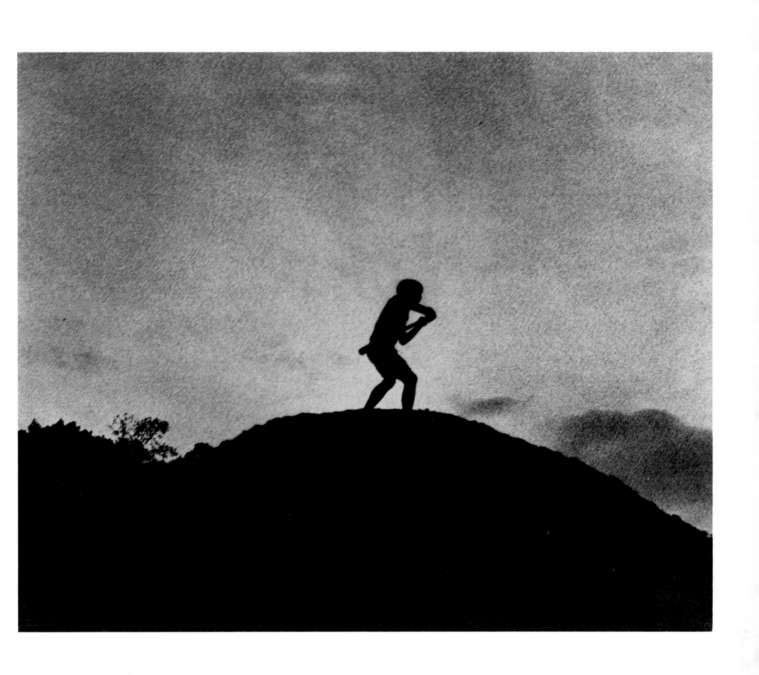

Our sons and daughters seek to establish a link with the past. They want to discover who they are, why they are here and where our destinies are to take them.

Patsy T. Mink
United States Congresswoman
State of Hawaii

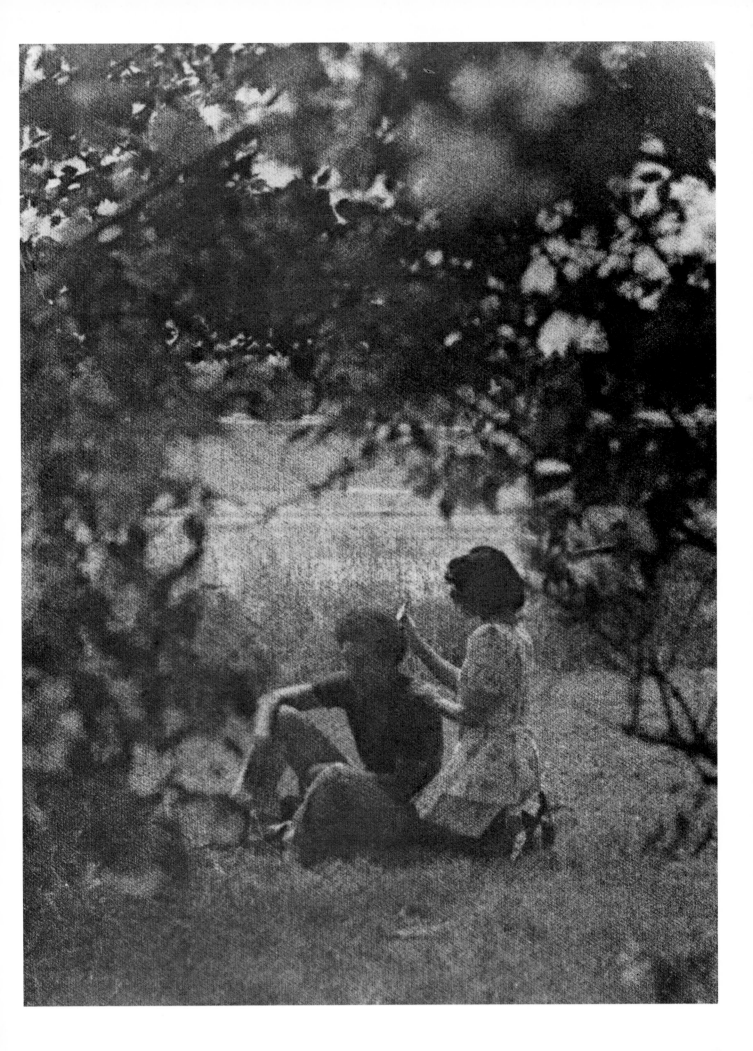

I would like to see every Negro
in this nation with a good education,
a good job and a good salary,
so that his city and state could tax him
adequately for the maintenance of the services
which he merits and the city requires.
I want to see the Negro move up
so that I can move up with him.

James A. Michener
Author *Quality of Life*

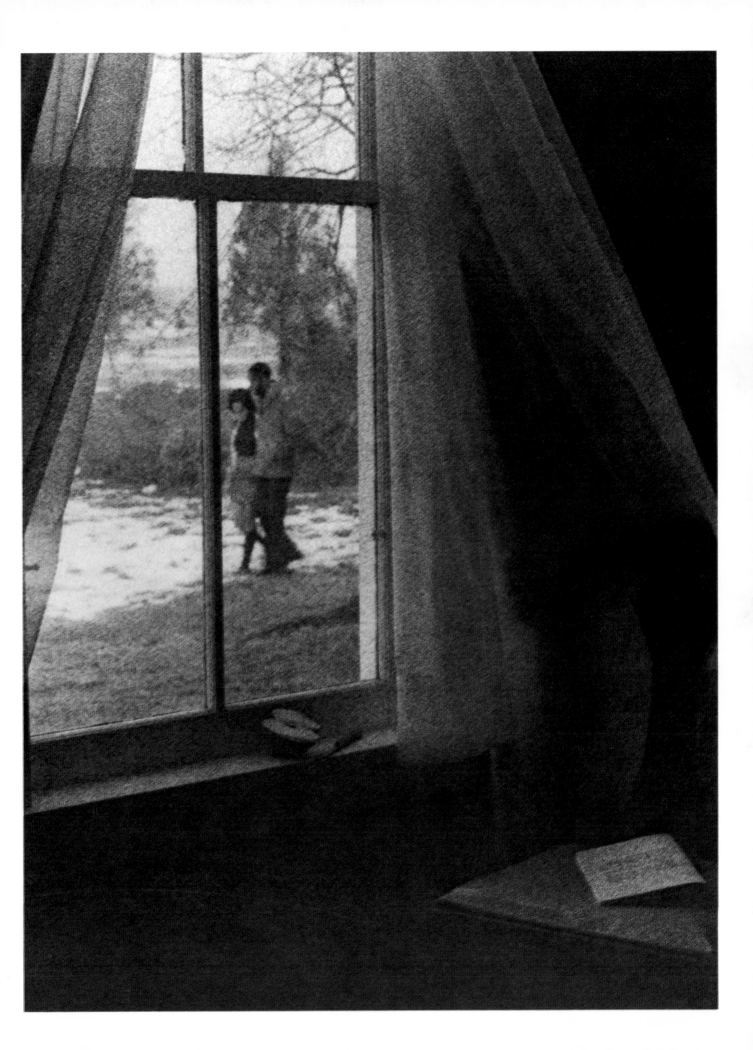

The world around us really belongs to youth,
for youth will take over its future management.
Our children must never lose their zeal
for building a better world.
They must not be discouraged
from aspiring toward greatness, for they are
to be the leaders of tomorrow.
Nor must they forget the masses of our people
are still underprivileged, ill-housed,
impoverished, and victimized by discrimination.
We have a powerful potential in our youth,
and we must have the courage
to change old ideas and practices
so that we may direct their power
toward good ends.

Mary McLeod Bethune, Ph.D.
American Educator

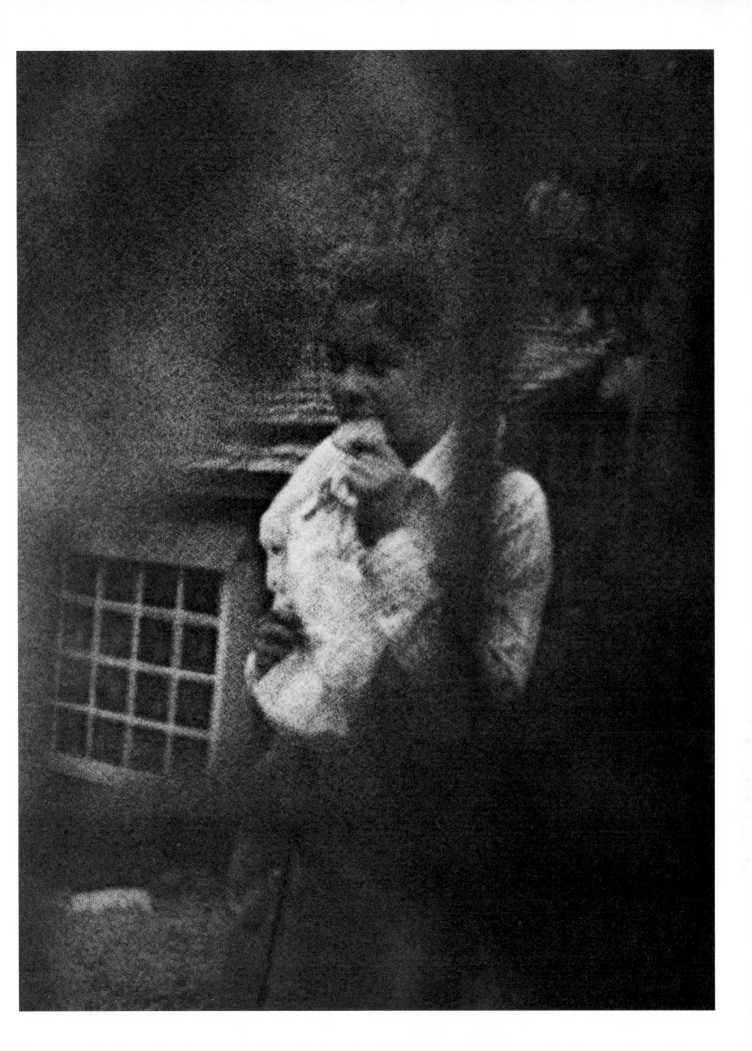

*Our system must maintain room
for the new groups,
and the new must allow the old
to maintain dignity.*

Nikki Giovanni, Author

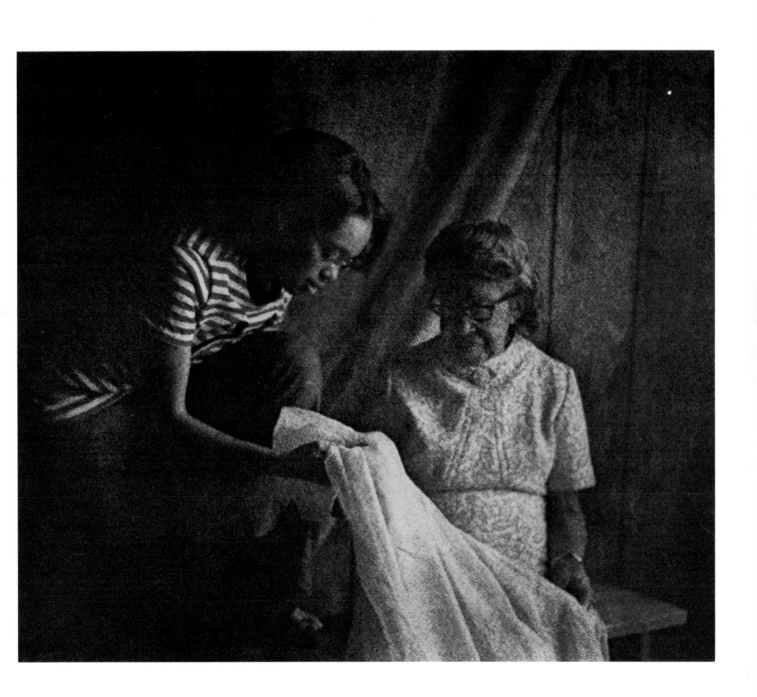

We are not born to be what we are.
We become what we are.
We are raised to expect a lot or
to expect virtually nothing.
We are given hope or taught fear.
We live in a time of progress,
or we live amid a
century's moment of chaos.

Robert Coles, M.D.
Author *The South Goes North*

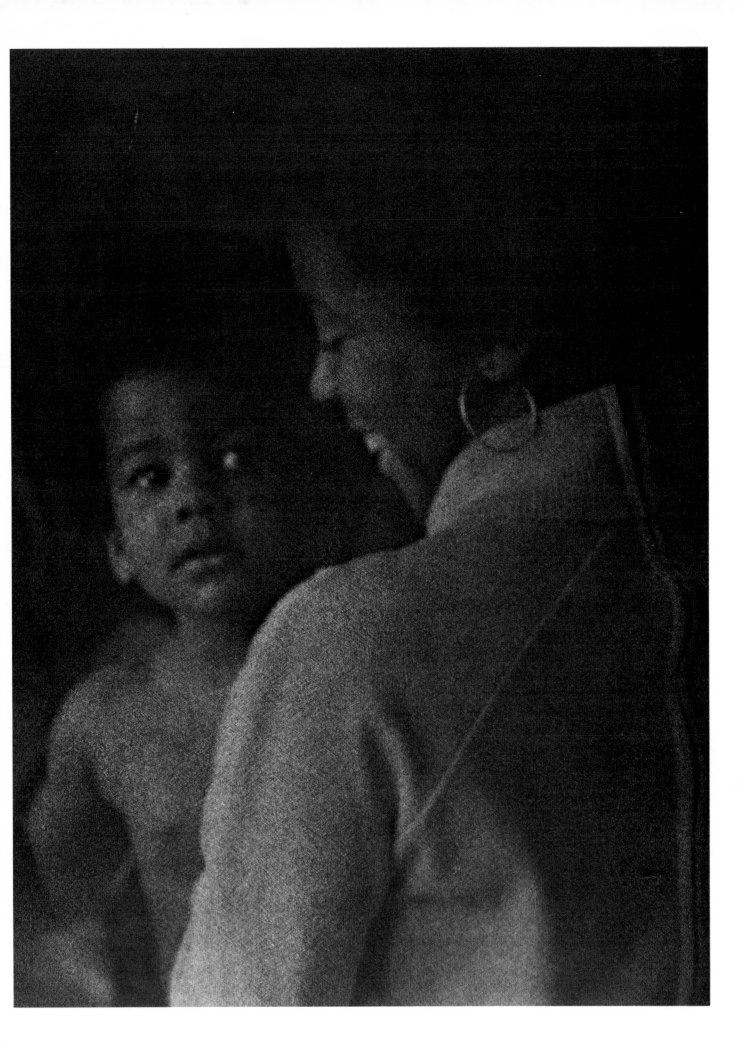

*The great marvel of our times is that so many
Negroes have been able to surmount
the fearful obstacles of our melancholy history
in this land and to achieve real distinction in a
wide range of honorable endeavors.
The educational, economic, political, and
psychological handicaps have been so staggering
that a less hearty people would have long since
succumbed to frustration and despair . . .
The catch-up process is painful and
time consuming . . . In an increasingly automated
society equality becomes meaningless without
adequate preparation to compete on equal terms
with one's fellow citizens . . . Segregation has been
the most potent force retarding the Negroes
as a group . . . With the demolition of the walls
of segregation, some Negroes will be unable
to retain their present status because their
performance will be measured by overall standards
rather than by parochial racial standards.
Come what may, we are on our way and
the new day already looms in sight.*

Roy Wilkins
Executive Director
N.A.A.C.P.

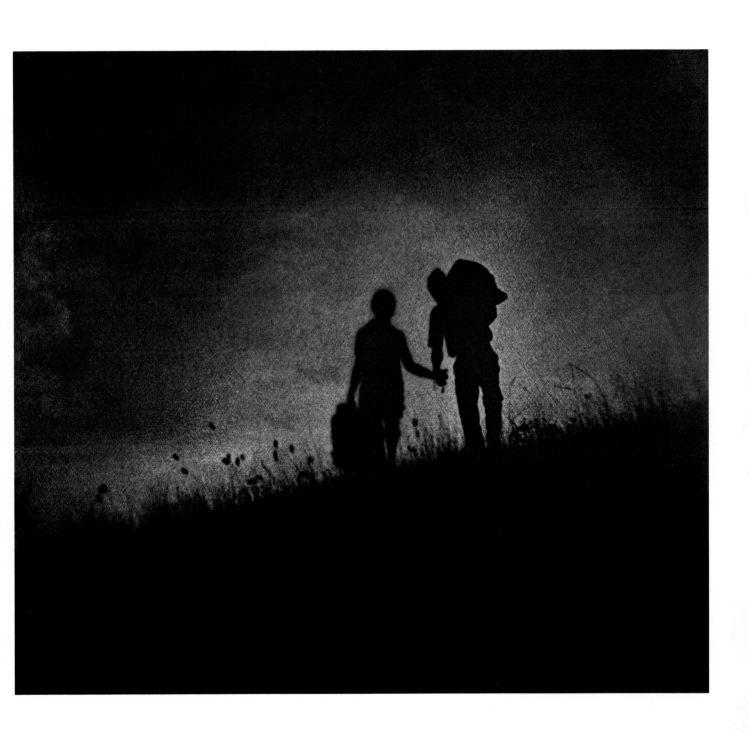

If I may be pardoned for a personal reference,
I am proud to be an American
and I am proud of my origin.
I believe in the American way of life,
and believing in it, deplore its imperfections.
I wish to see my country strong in everyway
— strong in the nature and practice of its
democratic way of life;
strong in the hearts and minds of all its people,
whatever their race, color or religion,
and in its unshakable devotion to it.
I wish to see an America in which
both the fruits and the obligations of democracy
are shared by all of its citizens
on a basis of full equality and
without qualifications of race or color.

Ralph J. Bunche
Nobel Peace Prize 1950

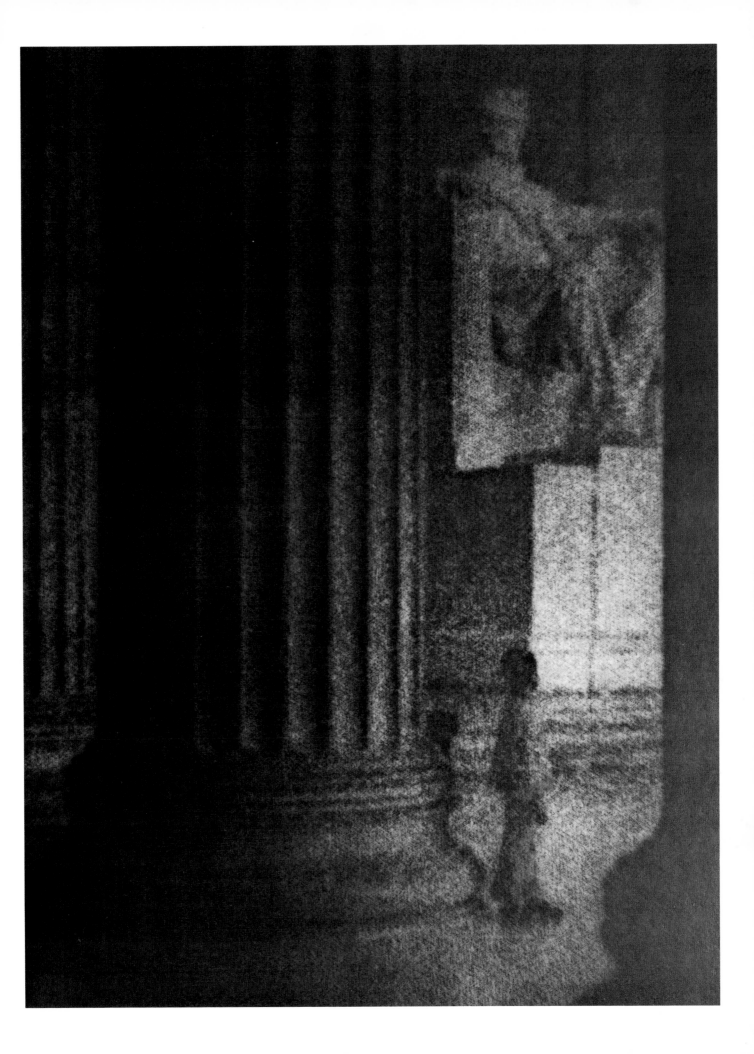

*"Some men see things as they are
and say why.
I dream things that never were
and say, why not."*

Robert F. Kennedy
United States Senator
State of New York

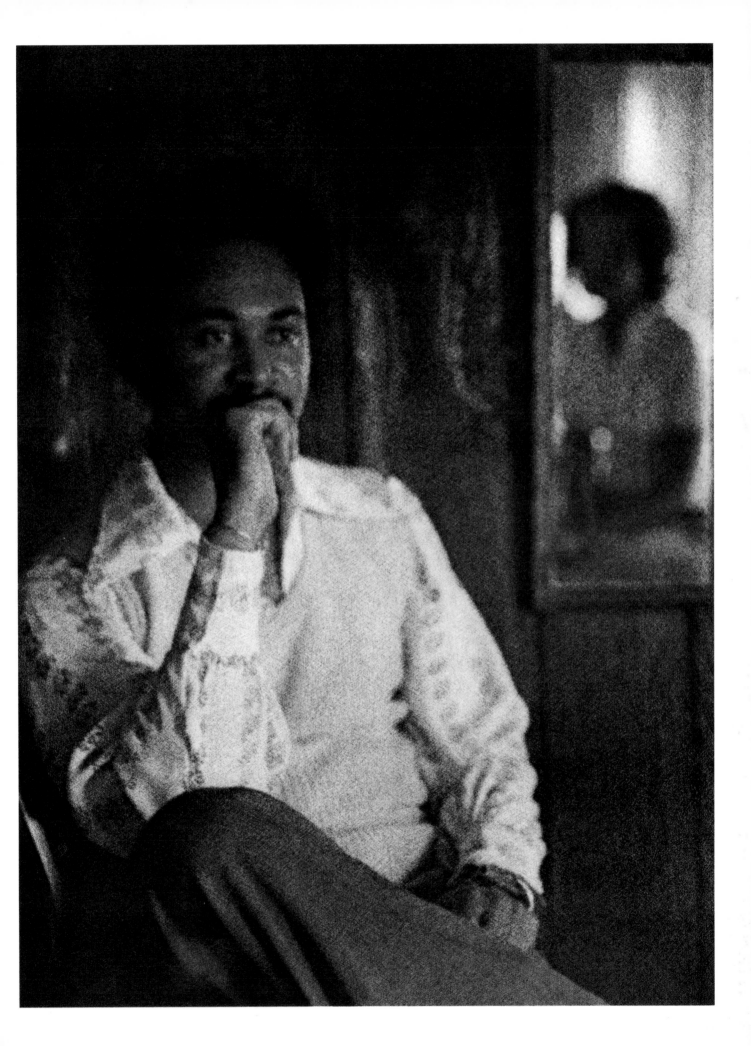

*Does color make
any real difference?*

160

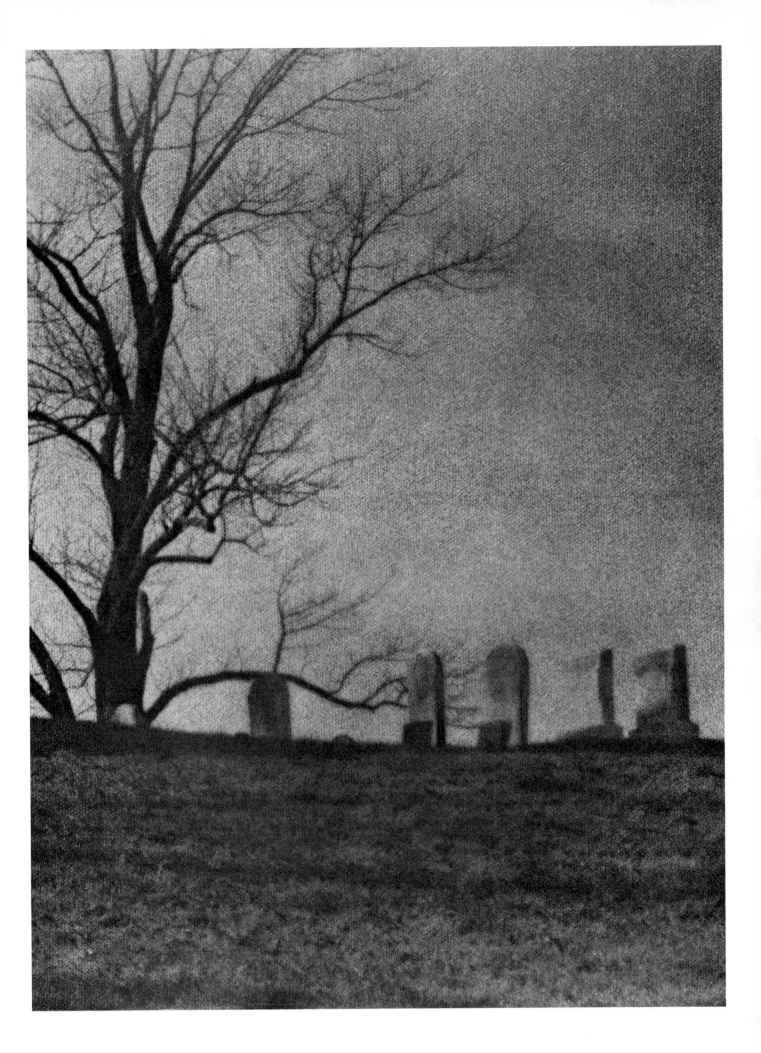

Negroes want in American Society,
and they want the ways opened now.
They reject separation,
whether advocated by the Black Muslims,
the White Citizens Councils,
or the Communist Party.
They are committed to a pluralistic society
with equal rights, opportunities,
and freedom for all.

Roy Wilkins
Executive Director
N.A.A.C.P.

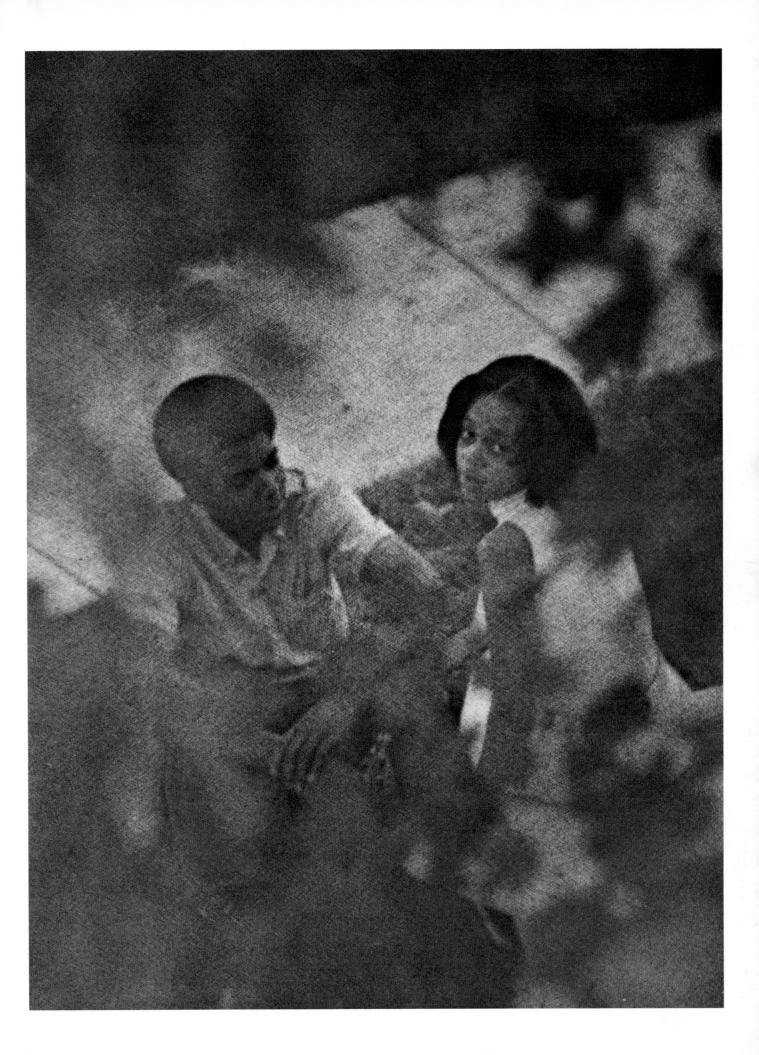

Take away an accident of
pigmentation of . . . our outer skin
and there is no difference
between me and anyone else.

Shirley Chisolm
United States Congresswoman
State of New York

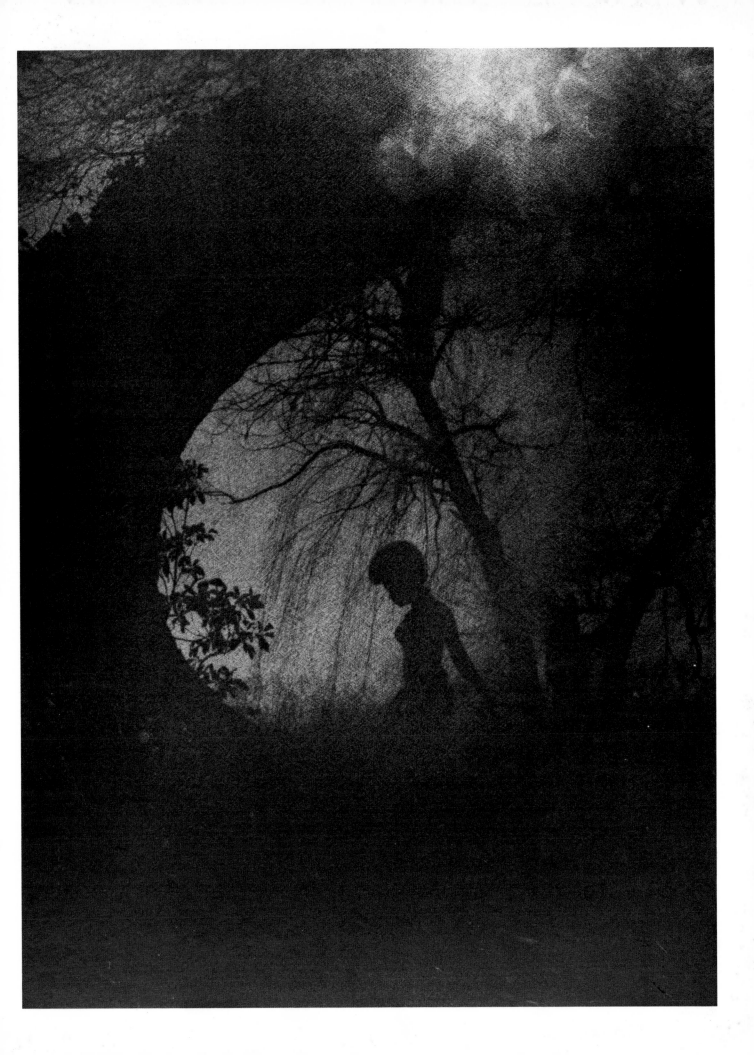

The text for this book was set in Bodoni and the
color separations and printing were done
by Vernon Martin Associates, Inc.
Lancaster, Pennsylvania. The first
edition of this volume
consisted of eight
thousand copies.